PORTSMOUTH
MURDERS AND
MISDEMEANOURS

DEAN HOLLANDS

AMBERLEY

It is with true empathy that I dedicate this book to the memory of the victims and their families, of the crimes included within these pages, and to all those who dedicate their lives to making our communities safer places to live.

First published 2022

Amberley Publishing
The Hill, Stroud
Gloucestershire, GL5 4EP

www.amberley-books.com

Copyright © Dean Hollands, 2022

The right of Dean Hollands to be identified as the Author of this work has been asserted in accordance with the Copyrights, Designs and Patents Act 1988.

British Library Cataloguing in Publication Data.
A catalogue record for this book is available from the British Library.

ISBN 978 1 3981 1007 6 (paperback)
ISBN 978 1 3981 1008 3 (ebook)

Typesetting by Hurix Digital, India.
Printed in Great Britain.

CONTENTS

INTRODUCTION

The challenge of undertaking research during a pandemic, and in compliance with its associated restrictions, meant writing this book was harder than I thought it would be. As a result, it has been more rewarding than I could have imagined.

True crime as a genre in writing, and in particular the subject of murder, is one that is well covered by writers, resulting in the same stories appearing time after in time, often to the frustration of readers and researchers looking for something different. Finding unusual cases, stories and accounts not previously explored presented yet another challenge.

In providing something that caters for the needs of new readers of the genre and those more acquainted with it, a balance must be had. In so doing, this publication presents a collection of known and forgotten misdemeanours and murders spanning several centuries.

Thanks to its geographical location, long-standing relationship with the Royal Navy, and the ever-present threat of war, Portsmouth's history is more colourful and diverse than most coastal cities. Over a millennium in the making, its citizens are rightly proud of their past, much of which is associated with significant military personalities and events.

However, the city also has a notoriously sinister, brutal and murderous past, full of terrible deeds, monstrous acts and barbaric judicial practices.

A detailed study of early court records, newspaper accounts and other criminal proceedings reveals a terrifying litany of criminal behaviour among the civilian residents and military personnel serving or visiting Portsmouth. The punishments meted out often matched the scale and horror of these crimes.

Portsmouth Murders and Misdemeanours contains a horrifying and chilling collection of real-life crimes. While some cases tell tales of cold-blooded murder, execution, assassination, attempted murder and murder-suicide, others tell of rebellion, revolt, riotous mourners and a siege at the funeral of a murdered child. Accounts of robbery reveal the true stories of Portsmouth's notorious highwaymen, a juvenile footpad who terrorised a community and a daring daylight raid by a violent gang of Auto-Bandits that sparked a nationwide manhunt.

Then there is the curious case of the teenager who brutally bludgeoned his mother and father to death with an axe before casually catching the train to London. Cases of fraud, deception and conspiracy abound in the trial of Britain's last witch. Not forgetting the offences of arson, terrorism and mutiny that rocked and terrified the nation.

Who knew Portsmouth had such a dark and gruesome history?

1. LAW MAKERS AND BREAKERS

Rooted in the codes, rules and laws of many ancient societies, Britain's legal system has developed into a system of social control based on compliance with constitutional laws (Civil Law) and precedents, laws decided by earlier cases and judicial opinions (Common Law).

Early punishments provided a lawful vengeance on perpetrators for the harm or loss they inflicted. They did not seek to educate, rehabilitate or reintegrate offenders. Their main purpose was to make the offender suffer physically, mentally or spiritually and, in time, financially. Today, punishments have several aims. Primarily, they penalise offenders and deter others from committing crime. After that, they protect society from the offender, and the offender from themselves; rehabilitate the offender in order to reintegrate them into society; and, finally, to provide reparation to victims and to ensure the law is respected.

This change in societies attitudes is reflected in the wide use of corporal punishment and death penalty during the Middle Ages for minor offences. In time, most societies have realised the value of educating criminals about their behaviour and reforming them. Using fines and public humiliation became appropriate punishments for less severe offences, and houses of correction (predecessors of prisons) were built for those most in need of further education.

Over time, crime types and what constitutes a crime have changed. In the Middle Ages, the most prevalent form of crime was harm, or the threat of bodily harm, and other actions committed against the will of an individual. As communities and individuals became more prosperous, crimes of theft, burglary and criminal damage became more frequent. Inevitably, offences of bodily harm accompanied these crimes. In response, the ruling class introduced new categories of crime and expanded criminal law to meet these changes.

Some aspects of human behaviour have always been criminal, such as murder, manslaughter, rape, burglary, robbery, fraud and forgery. Some acts, once considered criminal, no longer fall into that category; for example, suicide, abortion, witchcraft, sex acts between men and speaking out against the monarch or government. Other activities, taking laudanum, opium and cocaine, were once not crimes, but now are.

Some actions become illegal in times of war or civil emergency. During both world wars, spreading rumours, not blacking out houselights, buying food and materials from the black market, unauthorised keeping of diaries and being in unsanctioned locations without authority were among many activities considered illegal. Constraints on freedoms were made that restricted individual's movements and required identification cards to be carried at all times.

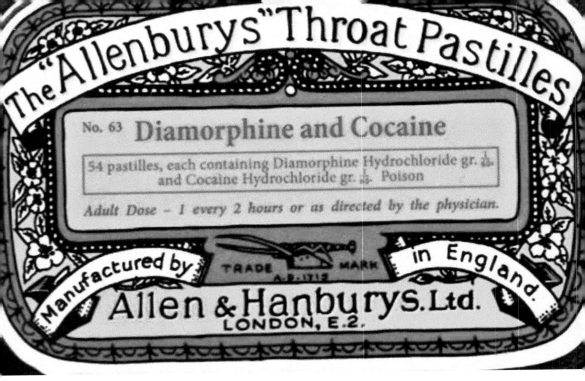

The "Allenburys" Throat Pastilles

No. 63 Diamorphine and Cocaine

54 pastilles, each containing Diamorphine Hydrochloride gr. 1/16 and Cocaine Hydrochloride gr. 1/8. Poison

Adult Dose – 1 every 2 hours or as directed by the physician.

Manufactured by Allen & Hanburys. Ltd. LONDON, E.2.

TRADE MARK in England

Above: 1870 advert, example of legal use of drugs.

Left: Wartime curfew notice.

City of London Police.

NOTICE TO ALIEN ENEMIES.

BETWEEN THE HOURS OF 9 P.M. & 5 A.M.

male alien enemies are required, with effect from 18th May, to remain at their registered places of residence unless furnished with a permit from the Registration Officer of the Registration District in which that place of residence is situate.

The Police are directed to enforce this restriction.

J. W. NOTT-BOWER,

CITY POLICE OFFICE,
26 OLD JEWRY,
LONDON, E.C.

NATIONAL
REGISTRATION

IDENTITY

CARD

1940s wartime identification.

Depiction of medieval Church Court.

Prior to the Norman Conquest in 1066, much of England's legal business took place in isolation in shire's folk courts, urban borough courts and at merchant fairs. Some large landholders held their own Manorial Courts, as did the Church, which tried religious crimes, blasphemy and not attending church.

Following the Norman Conquest, the legal system of England developed into 'The common law', because the law was 'common' to all the king's courts across England. Punishments prescribed through the various courts of medieval England ranged from fines, and shaming punishments for petty offences, to the death penalty for serious offences.

From the late thirteenth century in England and Wales, the court leet, a criminal court responsible for overseeing the standards in food and drink, weights and measures, agriculture, and all community matters, heard petty offences. It could investigate, judge and punish minor criminal offences such as social nuisances, land disputes and breaches of the peace. As the penal system developed, in England and Wales 'Quarter Sessions' and 'Assizes' courts with stronger sentencing powers were introduced to deal with more serious offences. During the 1970s magistrates' and crown courts abolished and replaced these.

Throughout the late medieval era, offenders whose behaviour was unchristian, antisocial or annoying were dealt with locally by being put in devices known as the pillory, hinged boards fixed to a post upon which individuals were secured by their wrists and neck, forcing them to stand for a period, or stocks, large hinged wooden boards at ground level that restrained individuals in a seated position by their ankles or wrists.

Portsmouth Magistrates' Court. (RD)

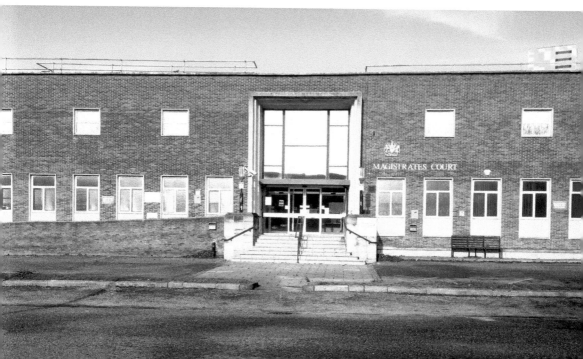

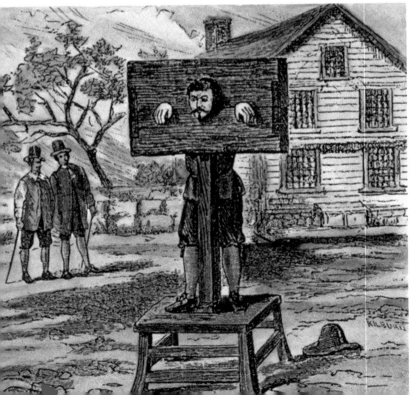

Above: Portsmouth Crown Court. (RD)

Left: The pillory.

Stocks and pillories were a short-term punishment, defined in hours whatever the weather, which often added to the offender's difficulties. Such punishments ensured public need for justice was satisfied and often formed part of a sentence that included imprisonment or temporary imprisonment on cramped disease-riddled prison hulks pending deportation to Australia. Once incarcerated in the stocks or pillory, offenders would be pelted with rotten food and the contents of chamber pots were often tipped over them. These shaming punishments were intended to embarrass and cause ignominy, although offenders were often left handicapped and maimed.

Some people were not so fortunate. The Monday edition of the *Hampshire Chronicle*, dated 8 May 1775, reported that James Cross was placed in the pillory at Portsmouth for an 'unnatural crime' (sodomy) and treated most cruelly by a mob. Not contented with throwing rotten eggs and apples, they threw large flint stones in such abundance that after twenty minutes, the mayor stepped in and ordered the mob to desist. Cross's head, eyes and face were described as being 'most terribly mangled' and he had lost over a quart of blood.

The level of violence witnessed, caused the mayor to issue warrants for the arrest of the ringleaders, who themselves were sentenced to spend time in the pillory. For maximum impact, offenders were punished at the scene of their crime. This meant most villages had stocks and a pillory in prominent places, usually outside ale houses, on the green, or in the Market Square where crowds often gathered. Today, these devices and most of the original sites no longer exist.

Convicts boarding a prison hulk, Portsmouth.

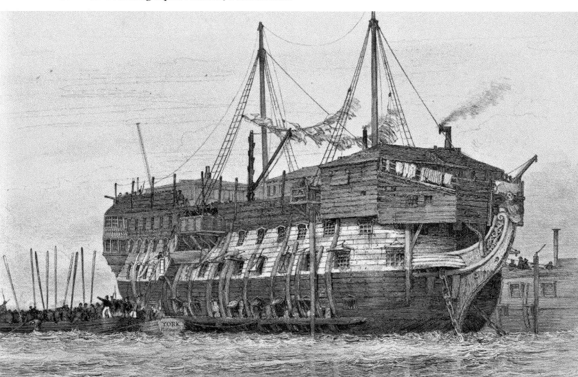

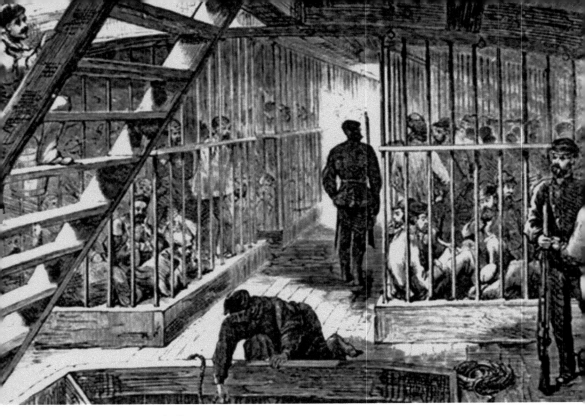

Life inside a prison hulk.

Records show stocks were in use on the Common at Old Portsmouth; outside the old police station, Ordnance Row, Portsea; and outside the George and Dragon pub at Kingston Road, Buckland. They also used pillories at the Market Square, the gates to the dockyard and on the Grand Parade at Southsea.

The remains of an original pillory post once stood within the courtyard of Southsea Castle but has since been removed. Not an original feature of the castle, it was used in the Portsmouth area and moved there later. Pillories were also used for more barbaric punishments depending on the severity of the offence. In the Middle Ages, an offender could have their ear nailed to the pillory for a theft up to the value of one shilling (10 pence). Upon release, they had to choose to have it cut off or wrench it off themselves.

Throughout the eighteenth century, thieves were branded and or had their eyes put out for thefts over a shilling. In England and Wales the punishment for both sexes for heresy was public burning at the stake. While men convicted of high treason were hanged, drawn and quartered, this method was not thought suitable for women as it would involve nudity. As a result, women were burnt at the stake in a variety of ways, having been first strangled slowly as they watched the wood piles being placed around them. If they were unlucky, they would be conscious as the flames began flicking about their legs.

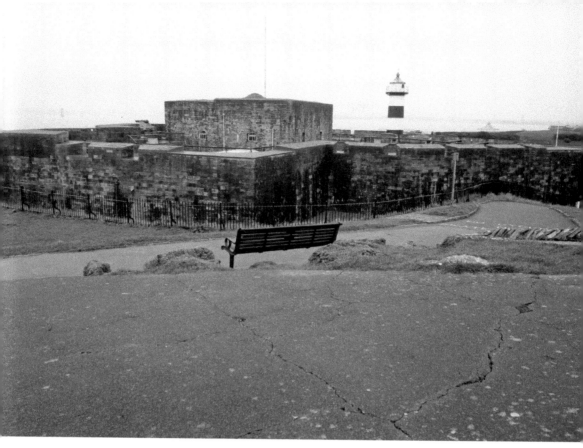

Above: Southsea Castle. (RD)

Right: Nailed to the pillory for a theft.
(© Dave Doody)

A heretic burning at the stake.

Tools of the coiners trade.
(© Dave Doody)

High Treason also encompassed several other offences, notably coining, which covered several offences relating only to gold and silver coins (e.g. clipping coins to provide coin metal for forgeries, colouring coins to make them appear of higher value, making counterfeit coins and having the equipment to do any of the above).

Male offenders were hanged, and females burnt at the stake, where as if a man murdered a woman or a man he could be hanged or burnt at the stake. Stakes were also used in tidal areas, for female murderers who would be tied to a stake during low tide, and left to drown as the tide came in.

The public whipping of offenders was commonplace until the mid-1850s, and whipping posts were often erected next to stocks. Once secured to the post, long hair was tied up, and the offender was stripped from the waist up, then whipped with a 'Cat of Nine Tails' for the prescribed number of lashes. Some offenders endured the added humility, of being whipped 'at a cart's tail', where prisoners were secured to the rear of a cart pulled by a horse along a public street or beach near the scene of their crime and whipped, until their backs were bloody. After such punishments, prisoners were returned to gaol and held until their fines were paid.

Stocks and whipping post, Northamptonshire. (© Oliver Dixon)

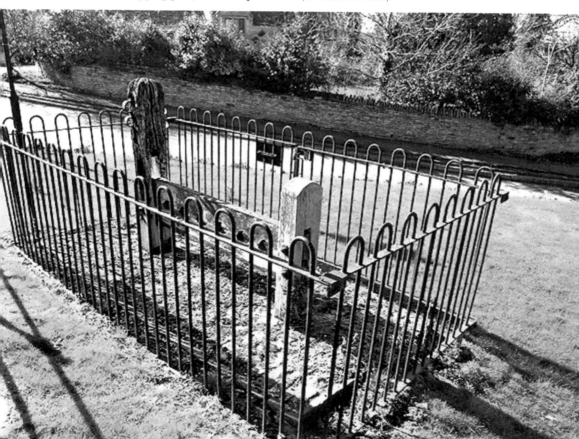

Whipping post, Norfolk. (© Richard Croft)

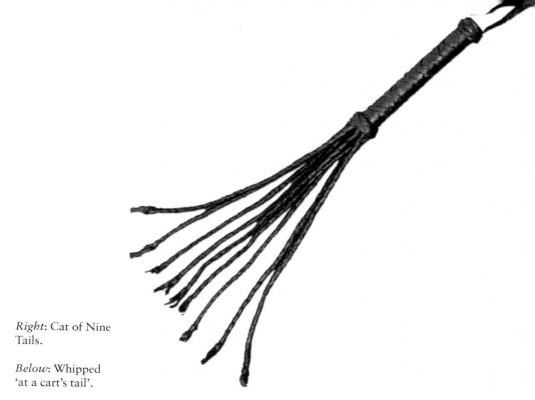

Right: Cat of Nine
Tails.

Below: Whipped
'at a cart's tail'.

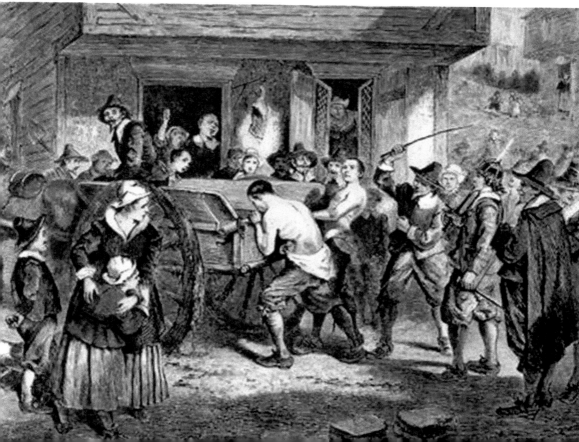

From 1720, courts differentiated between whipping punishments. Private whipping took place inside the gaol, prison or other correctional facility, as it was considered less humiliating than public whippings. However, the papers of the day, between 1750 and 1850, routinely carried reports in Portsmouth of public whippings at the Dockyard gates and other locations for theft-related offences. Among the hundreds of cases reported were Thomas Williams, who, on 28 April 1800, received one month in prison and was publicly whipped for stealing stockings and a handkerchief. Margaret Morgorven was imprisoned for one month and privately whipped for stealing printed cotton, while Joseph Hellyard, who stole a bullock's heart, received three months' imprisonment and was whipped in public. On 16 August 1802, Samuel Eckworth was whipped at the Dockyard gate for being in possession of the King's stores and Richard Andrews was placed in the pillory for being in custody of naval stores. On 23 October 1815, George Leverette, guilty of stealing three pieces of timber, was publicly flogged along Gosport beach for 200 yards.

The ducking stool was another form of corporal punishment designed to humiliate the offender. Derived from the cucking-stool, a covered chamber pot in a wooden seat, the ducking stool was used to punish men and women for various offences against the peace of the community, including drunkenness, gossiping and sexual offences. Some stools were set on wheels and dragged around the parish, so offenders could be punished at their door or the site of their offence. Offenders were tied into the seat and placed on public display, where they were pelted with stones, dirt and rotten vegetation.

In time, the ducking-stool was used to immerse offenders into water, acting as a swinging pillory or stocks. This punishment became reserved for dishonest brewers who sold bad ale and or bakers who gave short measure, in medieval times these were mostly women, along with scolds (people accused of being troublesome and angry, and who habitually chastised, argued, nagged, grumbled or quarrelled with their neighbours). As a result, many people died from drowning or shock from being plunged into freezing water.

The most serious offences (capital offences) carried the death penalty. By 1688, there were fifty such offences. This number had quadrupled by 1776, and by 1800 it stood at 220. By 1881 this number had been reduced to four, murder, arson in a royal dockyard, treason and piracy with violence. Further reforms followed, and the last public execution took place in 1868, after which all executions were conducted within prison walls.

While being buried, boiled alive, hurled from a cliff, beheaded, burnt or shot were common methods of execution during the medieval period, by the eighteenth century hanging had become the principal punishment for capital crimes.

In 1661, the Navy introduced the court martial, a penal code intended to deal with a wide range of offences from murder and sodomy to drunkenness, swearing and sleeping on watch. Death was an optional punishment depending on the offence and circumstances. High-ranking officers faced a firing squad and other ratings were hanged from a ship's yardarm.

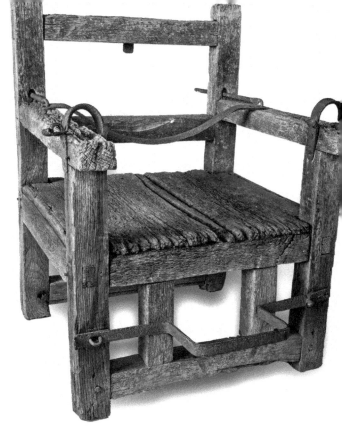

Right and below: Ducking chair.

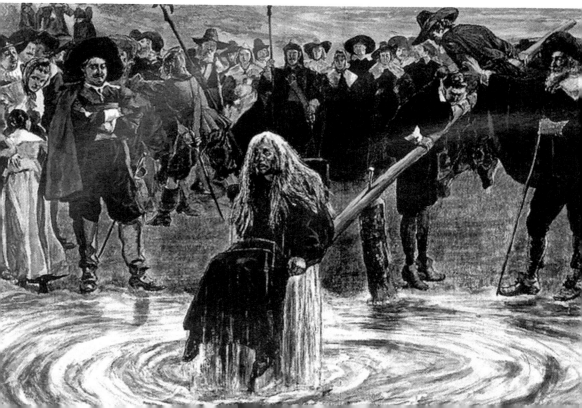

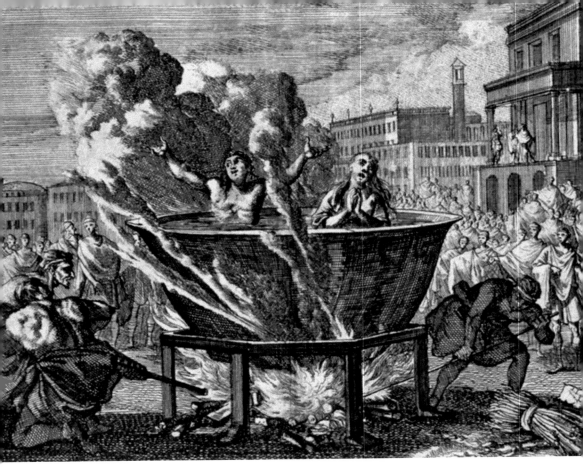

Above: Death by boiling.

Left: Hanged on the yardarm.

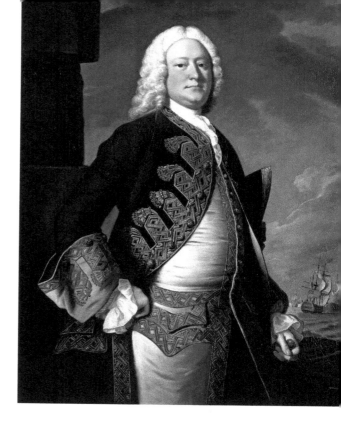

Admiral John Byng.

Admiral John Byng was the first and last admiral to be sentenced to death and executed by firing squad at Portsmouth. Byng joined the Royal Navy aged thirteen. Despite his quiet, passive and cautious nature, he rose steadily through the ranks and, by 1746, aged forty, he had become a rear admiral.

Ten years later, when the Seven Years' War broke out, Byng, now a full admiral, was ordered to prevent the French capture of the garrison Fort St Philip, a British stronghold on the island of Menorca. He set sail with ten leaking ships and barely enough men to sail them and headed for Gibraltar to collect 700 men from the island's garrison. From the outset, Byng made it clear he didn't have enough resources for such an operation and was leaving prepared for failure.

Following a brief skirmish with the French navy, who inflicted some damage to his leading ships, he allowed the French fleet to escape unchallenged, and sailed back to Gibraltar without relieving the fort. His intention was to repair his ships and get extra forces. Having reached Gibraltar, Byng learned the French had landed a substantial force on Menorca and were besieging the fort. He convened a council of war at which it was agreed that landing further troops would not stop the French and could cause a needless waste of life.

News of his decision aroused great consternation and fury in England. Outraged, King George II questioned why Byng would not fight and accused him of cowardice. Following which, news came to light of an earlier encounter that year between the French and the British fleet under Byng, from which the French had sailed away unchallenged. When Fort St Philip surrendered, Byng was

summoned home and upon his arrival was confronted by angry mobs baying for his blood and chanting 'Swing, swing, Admiral Byng'. Byng was arrested for breaching the 12th Article of War, which carried a capital punishment for officers who did not 'do their utmost against the enemy, either in battle or pursuit'.

At his court martial, which took place aboard HMS *St George*, in Portsmouth Harbour, 27 December 1756–27 January 1757, the court acquitted him of personal cowardice and disaffection, but concluded he had 'failed to do his utmost' in engaging and pursuing the enemy and sentenced him to death. Ignoring the court's unanimous recommendation for mercy, George II declined to spare him. On 14 March, at 7 a.m., in a howling gale and pouring rain, a heavy coffin was hoisted onto the flagship *Monarch*. Its plate was inscribed, 'The Hon. John Byng, Esq, died March 14th, 1757'. By 11 a.m. officers from every warship in the harbour and many other vessels were gathering around the *Monarch*.

At noon, fifty-two-year-old Byng came up on deck wearing a light grey coat, white breeches and a big white wig. According to the *London Evening Post*, 'he walked stoically to the quarterdeck in a stately pace and a composed countenance'. Before him stood nine marines in scarlet uniforms lined up in three rows, the rear row as reserve. At his feet were placed a cushion and a heap of sodden sawdust to soak up his blood. Beside him the coffin bearing his name.

Byng kneeled on the cushion, and accepted a blindfold, but only on the grounds it wasn't fair on the firing party to see his face. He tied the blindfold round his head and in his right hand he held up a folded white handkerchief, his signal for the six marines to fire. After an unbearable amount of time, Byng dropped the handkerchief and the marines fired. Their musket reports rebounded around the harbour and white musket smoke enveloped the admiral. When the smoke dissipated, Byng was slumped to one side, dead on the deck.

The execution of Admiral Byng.

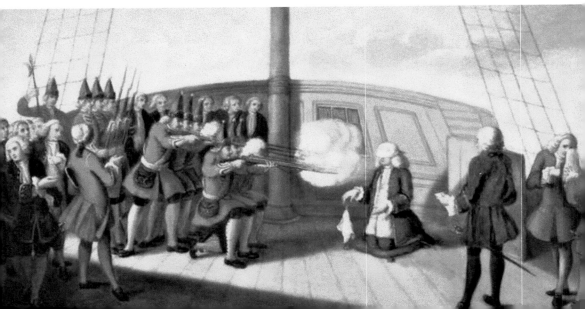

Naval hangings were public events, and on the day of execution, a yellow flag (the symbol of death) was flown from the masthead of the ship where the hanging was taking place. Soldiers and civilians from Portsmouth convicted of a capital offence were usually hanged in public at Winchester, but on occasions a common, or hill, on the outskirts of the town were used. Such events were rare and attracted vast crowds. In Portsmouth, Southsea Common was used for public hangings, and it has the distinction of being the location of the last public execution where convicted spy David Tyrie was hanged, drawn and quartered.

Around 40,000 people converged on Southsea Common on 24 August 1782 to see the gruesome execution of Tyrie, a civil servant in the Naval Office at Portsmouth who was caught selling vital naval information to the French. The throng watched in awe as Tyrie was hanged gasping for twenty-two minutes, lowered, and then made to watch as his executioner castrated him, removed and burnt his bowels. His head was then removed, and his body cut into four pieces. His remains were placed in a coffin and buried on the beach, and at once disinterred by entrepreneurial sailors, who cut the remains up into 1,000 pieces and sold them as souvenirs.

Reserved for murderers, robbers, pirates and smugglers, gibbeting was a post-execution punishment intended to make an example of criminals while humiliating them and their families. Gibbeting, a barbaric practice, dates back to the early medieval era and lasted until the eighteenth century.

View across Southsea Common. (© Peter Trimming)

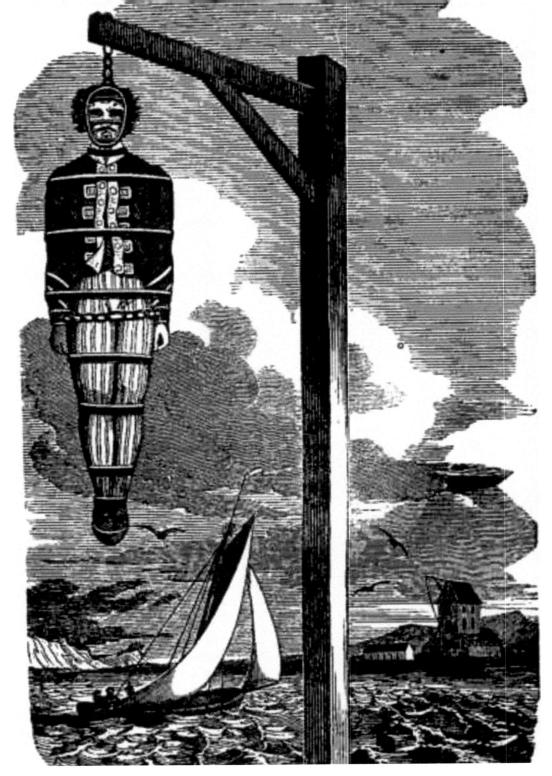

This page and opposite page: Gibbeted.

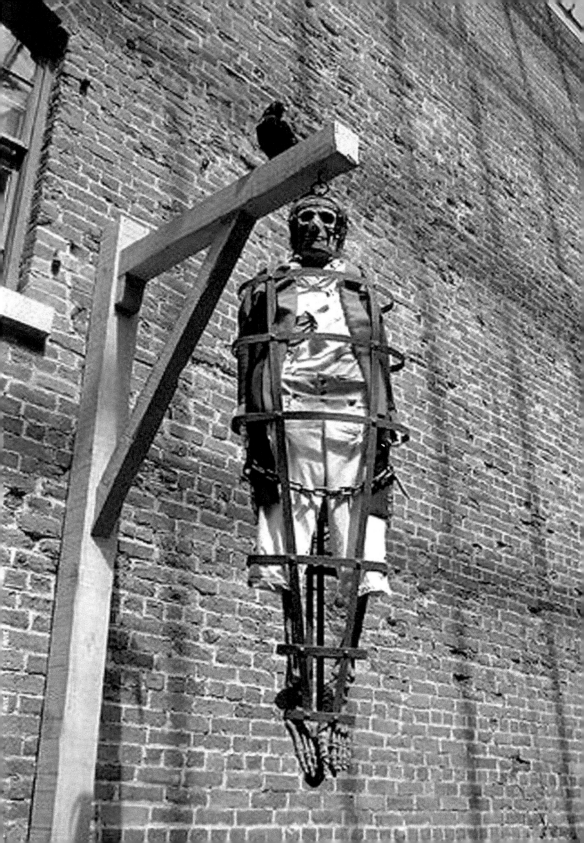

Having been hanged, the criminal's body was locked into a human-shaped cage, or wrapped in chains, and then hung from a wooden structure in a public place, usually at the scene of their crime. They were left hanging and decaying for several years as a warning to others. The Hampshire countryside was peppered with gibbets. They created fear that the executed individual would not receive a proper burial, be denied resurrection in the afterlife and damned for an eternity in hell.

A number of offenders with naval connections were gibbeted on the coast of Portsmouth between 1766 and 1881. Francis Arsine, a sailor, stabbed and murdered another sailor, Peter Varley, in 1766. Found guilty, he was ordered to be hung in chains at Blockhouse Point in Portsmouth dock. Two years later, James Williams, a sergeant of the marines, was hanged and gibbeted on Southsea beach for committing murder. In 1777 James Aitken, aka 'John the Painter', convicted of attempting to burn down the dockyard, was hanged in Portsmouth and then gibbeted at Blockhouse Point.

In 1779, Midshipman Murphy, an American taken into the service of the British navy in New York, was court martialled for mutiny and executed in the harbour on board HMS *Culloden*. He was buried directly under the gibbet on which James Aitken still hanged. In 1781 John Bryan, convicted of murder, was hanged in Winchester, and brought to Portsmouth where he was gibbeted near to James Aitken, whose body remained gibbeted until 1820. The Blockhouse became associated with gibbetting, and the punishment of sailors. Even when the bodies were eventually removed, the gibbets remained for decades, themselves serving as a reminder, warning and, sometimes, places of informal pilgrimage.

The gibbet located on Clarence Esplanade, Southsea, was used to hang John Felton, who, despite murdering the Duke of Buckingham in the Greyhound Inn (now the Ye Old Dogge Guest House) in 1628, was viewed by many as a national hero. When his gibbet fell, it was replaced in 1782 by an obelisk that doubled as a boundary marker and unofficial memorial. The obelisk disappeared during the 1930s and 1940s.

Riding the wooden horse was a punishment first devised by medieval religious fanatics to torture women who they forced to straddle the painful cross beam, with weights added to their feet. In the late sixteenth century, the English army adopted the practice for offences of rioting and drunkenness. Planks nailed together formed a sharp 9-feet-long ridge supported by four 7-foot-tall posts. When sentenced to 'ride the horse', a soldier was placed on the structure with his hands tied behind his back, and muskets tied to his feet to prevent him from falling off and to increase the pain caused by the downward pressure on the ridge. The remains of one of these devices were recorded standing on the parade at Portsmouth in 1760.

As time passed, the use of corporal and capital punishments to frighten potential offenders into compliance with the law ceased to be a public spectacle. Stools, stocks, pillories and gibbets disappeared from the landscape, replaced with fines,

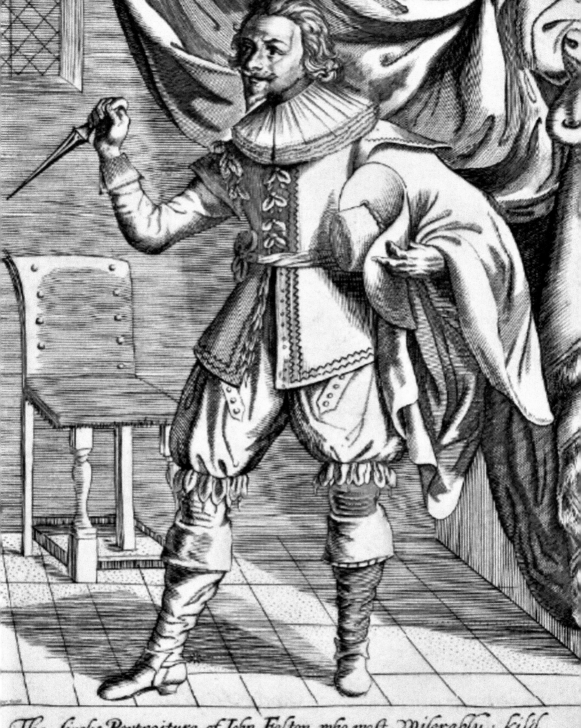

The lively Portraiture of Iohn Felton who most Miserably kild
The right Hono:ble GEORGE VILLEIRS Duke of Buckingham August ye 23. 1628.

Artist's impression of John Felton.

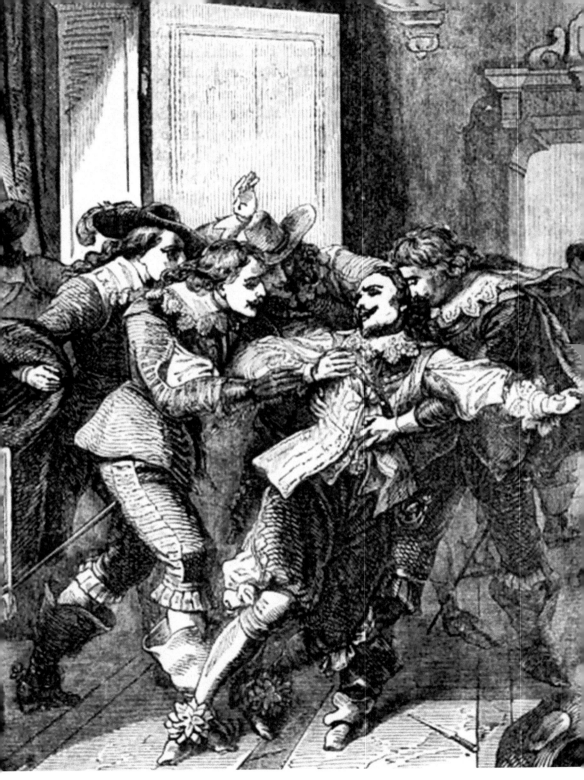

The Duke of Buckingham's assassination.

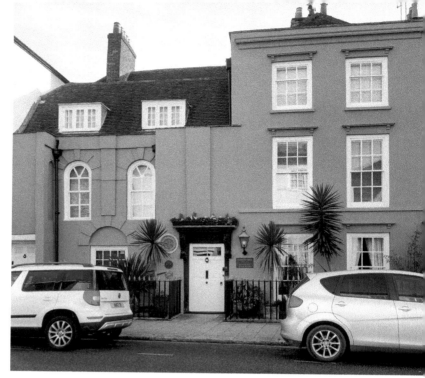

Ye Old Dogge
Guest House.
(RD)

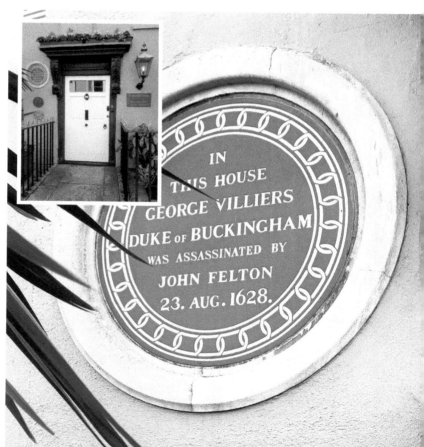

IN
THIS HOUSE
GEORGE VILLIERS
DUKE OF BUCKINGHAM
WAS ASSASSINATED BY
JOHN FELTON
23. AUG. 1628.

Ye Old Dogge
Guest House.
(RD)

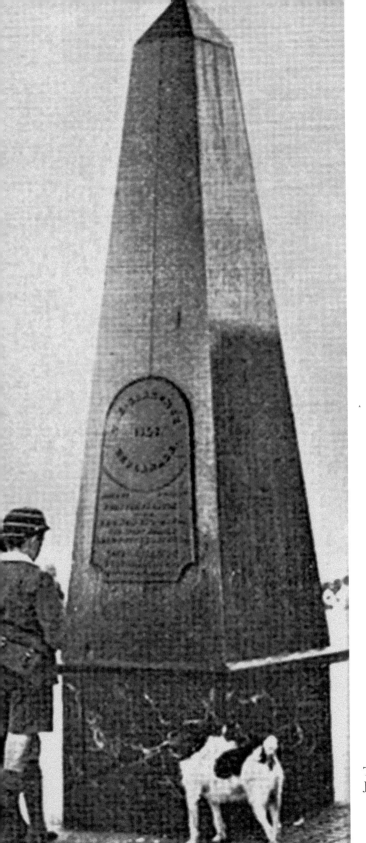

The disappeared obelisk to
John Felton.

Military wooden horse.

imprisonment, transportation and non-public hanging. While transportation and hanging became obsolete, a glance through the local and national papers reveals today, more than ever, people continue to engage in criminality, resulting in murder, serious assaults, robbery and many lesser misdemeanours. Nowadays, such crimes are every bit as common, heinous, debased, cruel and brutal as those committed in centuries past. No doubt they will provide material for books such as this for centuries to come.

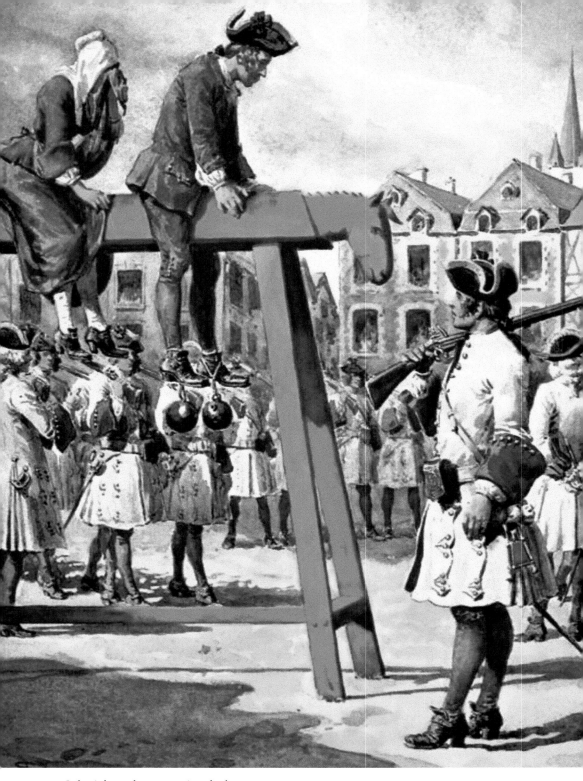

Colonial royal troops using the horse.

2. CRIMES OF PASSION

ALICE GAMBLIN: 'ARE WE TO BE MURDERED AND YOU'LL NOT INTERFERE?'

On 12 November 1887 onlookers packed the public galleries at the Winchester Crown Court keen to hear the fate of a star-crossed lover who, a month earlier, had, in a jealous fit of premeditated malice, tried to take the life of the one he prized. Alfred George Prior, nineteen, now stood in the dock charged with attempted murder and facing life in prison.

Portsmouth police described Alfred as a man of low intelligence, who had taken a job as a skin dresser, shaving and paring leather, for Mrs Ward, in the former Elephant and Castle beer house, No. 87 Saint Mary's Road, Kingston, Portsmouth. He also lodged there, along with fellow worker Mr Feltham (twenty) and house maid Alice Maude Mary Gamblin (nineteen).

Alfred, smitten with Alice, endeavoured to win her affections at every opportunity. Alice, a steady and respectable young lady, repeatedly told Alfred she was not interested in him, objected to his drunken habits, that she was engaged to another, and his romantic behaviour was not welcome and unacceptable to her parents, who objected strongly. However, Alfred continued to force his company upon Alice, causing frequent quarrels between them.

On the evening of 11 October 1897, Alfred returned to his lodgings drunk and immediately caused a disturbance. Using foul and abusive language, he insulted and threatened Mrs Ward and Alice, putting them in fear for their lives. Mrs Ward sent Alice to fetch the police to remove him, but the desk sergeant told her because Alfred lodged at the house and ate and drank there, there was nothing they could do. At which Alice angrily snapped, 'Are we to be murdered and you'll not interfere?'

Eventually Alfred went to his room, and the following morning Mrs Ward informed him he could no longer live at the address and was to leave that day. Alfred said he owed her eleven shillings and offered to pawn his clothing to repay her. Mrs Ward said she didn't want the money, and if he sought lodgings elsewhere, he could continue to work for her.

On seeing Alice, Alfred tried apologising, but she refused to accept, causing another heated dispute between them, prompting Alfred to storm out of the house with his belongings. Mrs Ward thought he had gone to secure new lodgings but unbeknownst to her, he'd pawned his clothes and bought a small, six-chambered revolver and a box of cartridges from the gunsmith in Commercial Road.

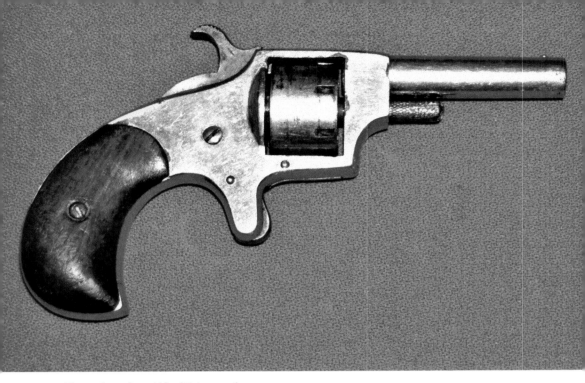

Type of revolver Alfred Prior used.

Alfred returned to the house at around 10.40 a.m. and entered the kitchen, a spacious room which had been the taproom when the building was a beerhouse. Mrs Ward was sitting at a table having a cup of coffee and Alice was sitting beside the fireplace, peeling potatoes. Alfred stood by the window on the same side of the room as Alice and opposite the door to the backyard.

Just before 11.00 a.m. Mrs Ward left the kitchen, heading toward the skin-dressing shed in the backyard. Alice turned her back on Alfred and knelt beside the fireplace, continuing to peel potatoes. About five minutes later, she heard a loud crack and felt a sharp pain in her lower abdomen. Alfred had shot her. The bullet passed through her, ricocheted off a table and struck a wall, before coming to rest on the floor. Wounded, shocked and bleeding, Alice dashed across the kitchen, through the door and into the passage leading to the backyard. As she reached the door, Alfred fired a second shot, which missed, embedding itself into a floorboard.

Alice, panicking and sobbing loudly, ran towards Mrs Ward, who having heard the shots entered the backyard. Alice shouted, 'Oh, my, Alfred has shot me!' Mrs Ward took hold of Alice and, supporting her, hurried out into St Mary's Road. Alfred appeared in the yard, aimed his pistol at them and fired. The bullet missed Alice and lodged in the woodwork of the gate beside her, 4 feet from the ground.

Charles German, a retired inspector of the Borough Police force, and Mr Sibbick, a fruiterer and greengrocer of Kingston, were passing and also heard the shots. They saw Mrs Ward and Alice running across the road, waving their

hands above their heads, and screaming they were being shot at before entering the draper's shop opposite.

German and Sibbick entered the yard as Alfred appeared from the passageway and said, 'It's me you want. I shot the girl, take me to the police station. They gave me warning to leave and it upset me very much'. German detained Alfred and ordered a passing boy to fetch a doctor and get the police. German then took Alfred into the kitchen and asked him where the pistol was. Alfred made no reply but reached into his left trouser pocket and pulled out the weapon and a box of cartridges. German took them from him and was holding the pistol down by his right side when Alfred said, 'Put that out of sight. I don't want everyone to see it'. Mr Sibbick joined them and asked Alfred what had happened. Alfred confirmed he had shot Alice. When Mr Sibbick asked why? He stated they had rowed the night before and again in the morning. At which point Police Constable Wright joined them, handcuffed Alfred, and arrested him for attempted murder.

As he was being escorted away from the house, a neighbour, Mrs Everson, asked Alfred what he had done? He replied, 'I don't know Mrs Everson. They should not have upset me, then they would not have had it. If they upset me, they have a fucking rum one to deal with'.

Dr Hackman arrived, examined Alice and administered her emergency treatment to stop the bleeding. He then arranged for a hansom cab to take her to hospital, along with Mrs Ward and two neighbours. Alice underwent further examinations and medical treatment before doctors revealed her injury was serious but not life-threatening. Alice remained in hospital for five days.

While searching the scene, police recovered three bullets matching those in Alfred's possession. They seized the gate with the bullet lodged in it and later produced it at court as evidence of Alfred's intent to murder Alice.

On Thursday 13 October, Alfred appeared before magistrates charged with shooting Alice with intent to murder. Following a brief presentation of the evidence, magistrates remanded him in custody for a week while a full investigation took place. After that he reappeared at court, and they remanded him in custody to stand trial at Winchester Assizes on 12 November. His indictment stated he was accused of feloniously shooting Alice with a revolver with intent thereby to kill and murder her at Portsea on 12 October.

A judge heard the case against Alfred. During the trial witnesses gave evidence, and the prosecution read out Mary Lean's deposition, a neighbour unable to attend court. Mary stated four or five weeks before the shooting, Alice had been at her house when Alfred came looking for her. Alice fled and Alfred stated that 'he would either have Alice or the bitch's life'.

Remarkably, while giving evidence, Mrs Ward informed the judge that if he released Alfred, she would allow him back into the house! Not as remarkable as the comments and behaviour of the judge towards the jury in his summing up.

First, he said he would not insult their intelligence and ask them to acquit Alfred altogether. However, he begged them to consider the circumstances

carefully, and conclude his act, though extremely foolish and wicked, was not as serious as set out in the principal count in the indictment, and they should find him guilty of unlawful wounding only! The judge submitted that Alfred and Alice were now on perfectly friendly terms and there really was no motive to induce him to make another attempt on her life. He strongly contended Alfred had done this out of sheer brag and bluster, 'merely intending to frighten her'.

The jury retired to consider their verdict. After three minutes of deliberation, they returned and, despite the judge's best efforts to influence them, informed him they found Alfred guilty of shooting Alice with intent to murder. In passing sentence, the judge told Alfred he had no choice but to sentence him to twenty years' penal servitude. To which Alfred replied, 'Thank you, your Lordship'.

ELIZABETH HARRISON: 'SO SUDDEN I WAS FORCED TO YIELD MY BREATH'.

In the grounds of St Peter and St Paul's Church, Wymering, stands a fine headstone marking the grave of Elizabeth Harrison, a twenty-seven-year-old lady's maid, who died in the most brutal of circumstances, at the hands of the man she loved, but who did not love her.

Elizabeth was smitten with Stephen Burghes, a labourer living at Little Wymering Farm, and during the spring and summer of 1772 she had taken to following him daily, across the estate, from field to field, making her feelings known to him. Despite Stephen discouraging her, Elizabeth's pursuit of him became too much for the object of her heart's desire and he decided enough was enough.

St Peter and St Paul's Church.

Wymering Manor in 2007.

A blunderbuss.

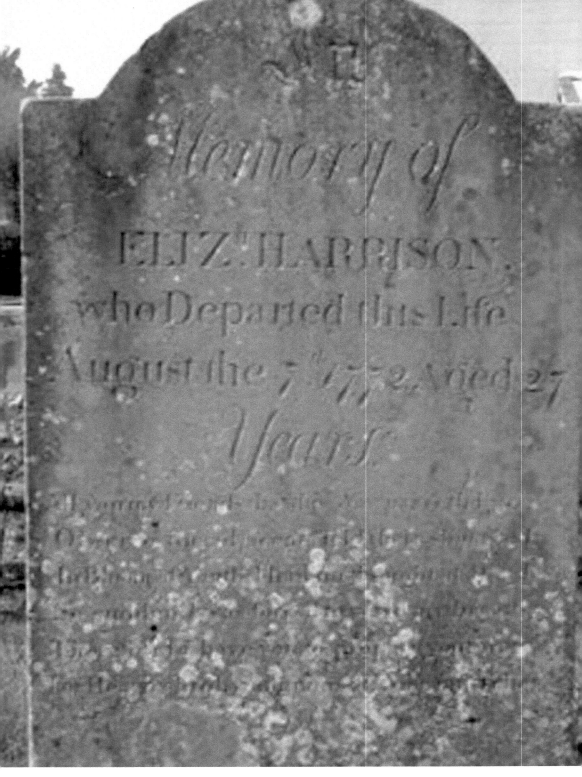

Elizabeth's grave. (FG)

On 7 August, Elizabeth left Wymering Manor, where she was employed. She once more trailed after him, across field after field, until they reached a field close to St Peter and St Paul's Church. There, with no warning, Stephen produced his 'blunderbuss' and shot her in the face at close range. Elizabeth died instantly, and Stephen was at once arrested. Her family buried Elizabeth two days later, and villagers from miles around attended the funeral.

The judge at the Winchester Assizes found Stephen guilty of murder and sentenced him to death. However, unusually for a farm worker Stephen was literate and able to read the 'neck verse', a means by which first-time offenders could obtain partial clemency for some crimes and avoid the death penalty by reading a text selected by the judge.

Convicts who successfully pleaded benefit of clergy had their punishment reduced to stigmatisation and branded on the thumb with a relevant letter: 'T' for theft, 'F' for felon or 'M' for murder. This ensured they did not receive this benefit more than once. The branding took place in the courtroom at the end of the sessions in front of spectators. They used other letters at the time to distinguish between crimes: B – Blasphemy, P – Perjurer, R – Rogue, S – Slave, SL – Seditious Libeller, S – Sower of Sedition and D – Deserter.

Branding irons.

The inscription on Elizabeth's headstone, still visible today, reads: 'In Memory of Elizabeth Harrison, who departed this Life August 7th, 1772, Aged 27 years. All you my Friends that this way passeth by Observe the adjacent field there shot was I, in bloom of Youth I had no thought of Death, so sudden I was forced to yield my breath. Therefore I'd have you to prepare your way. For Heavens high Summons all Men must obey.'

FRED (EDWARD) WOODWARD: 'I TAKE THE GIRL I LOVE WITH ME. GOD BLESS HER'

It was a grim and most unpleasant task and not one either George Dumper, a Bombardier of the Royal Garrison Artillery (RGA) stationed at Clarence Barracks, Portsmouth, or Charles Dyer, a local merchant mariner, ever thought they would have to perform. Yet here they were on a Friday evening in the company of fourteen strangers standing in a cold, dimly lit room wreaking of carbolic acid.

Before them were two tables, each supporting a body covered by a white sheet. At the direction of the coroner, Mr Bramsdon, a police officer, stepped forward and turned back a sheet to reveal the ashen face and half-closed eyes of twenty-five-year-old Edward Charles Woodward. George had known Edward for eighteen months during their time together as gunners in 37 Company RGA.

Having replaced the sheet, the officer moved to another table, repeated the action to reveal the face of twenty-six-year-old Mary Anne Elizabeth Prescott. Mary, a married woman known to all as Mrs Dyer, who, during the previous seven years, had lived at No. 12 Lombard Street, with Charles, her husband, and their six-year-old daughter. In life, Mary took good care of her appearance. She had a warm smile and sparkling eyes. In death, her face and hair were a mess, caked with dried blood, her lips hard and blue, her gaze a frozen sadness. Charles did not know of Edward and neither knew anything of the circumstances of their deaths.

Each member of the group, having viewed the two unfortunate bodies, solemnly made their way out of the mortuary back towards the Town Hall where earlier the coroner Mr Bramsdon had opened an inquest to establish the identity of the deceased, the cause of their deaths and circumstances in which they died. Reconvening proceedings, the coroner began calling witnesses and experts to answer his questions. With each witness, a story emerged, and by the time the coroner called the last witness, he had established the facts of that story.

In June 1904, Mary had introduced herself to Edward as a single woman. Her petite and prepossessing appearance instantly beguiled him and over the next twelve months, while Charles worked as a steward onboard a steamer, they met in and around the town and in various public houses. During this time, Mary kept up the pretence of being unattached. When they met at the Duke of Buckingham public house, they would always arrive and leave separately. Mary always called for and bought her own drink. Customers in the pub had seen the pair together

Site of No. 12 Lombard Street today. (RD)

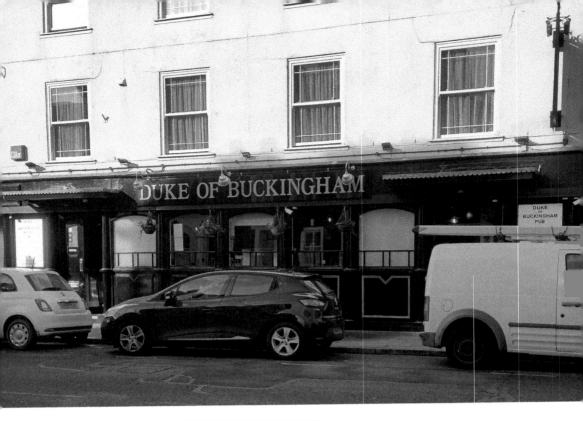

Above: Duke of Buckingham
pub. (RD)

Left: Duke of Buckingham
pub. (RD)

many times during the previous twelve months, and they always seemed on friendly terms.

On 8 July 1905, Charles was on night duty and left for work at 6.00 p.m. After waving him off and putting their daughter, Amy, to bed, Mary went into the old town, arriving at the Duke of Buckingham at 8.20 p.m. Having entered the private bar, she purchased a glass of stout and stood at the counter reading a copy of the *Evening News*.

Unknown to Mary, Edward was drinking in the public bar next door with other members of his unit, where he remained for a while before leaving briefly. Upon his return, he joined Mary at the counter and the two entered what was described by barmaid, Mrs Moore, as a 'most friendly and agreeable conversation'.

At 20.35 p.m., the couple were still at the counter facing each other, but no longer talking. Edward had his head on his left hand with his elbow resting on the bar, staring intently at Mary, who was reading the paper. When the proprietor, Mrs Chandler, appeared, Mary asked her if she could come to the Empire Theatre with her. Mrs Chandler agreed but said there wasn't much time, at which point Edward said, 'You will not go to the Empire'. Chandler told him to 'shut up' and to 'let her go' and then moved into the public bar.

Artist's impression of murder suicide.

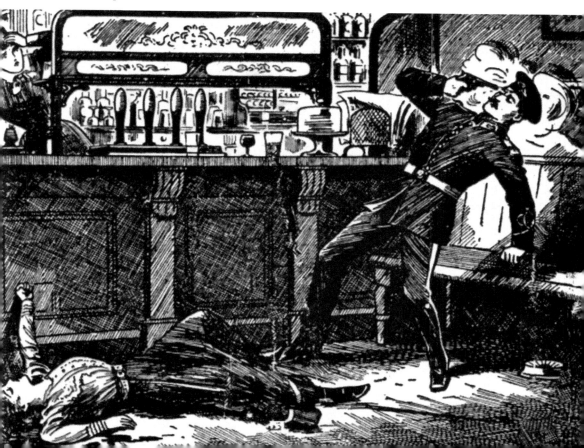

With no one else in the private bar, the barmaid, Mrs Moore, went to serve in the public bar and almost immediately heard a shot followed by two more in quick succession, and then the dull thud of two bodies falling onto the wooden floor. Fearing a lunatic was running a mock with a gun, the terror-stricken customers fled into the street.

After a brief period, Henry Blackman, a resident at the Buckingham pub, entered the private bar and found Edward lying face down on the floor in a pool of blood with a regulation army pistol in his right hand. He removed the weapon, placed it upon a seat and went across to Mary, who was dead and laying on her back, her head resting in a pool of blood that was seeping across the floor. He went back to Edward and, turning him over, realised he was still alive. Blackman fastened the door to the private bar and went to fetch the police.

The witnesses' evidence established Edward was madly in love with Mary and had become infatuated to the point he resented any of his comrades talking to her, and when they were out together, he guarded her most jealously from their attentions.

In recent weeks, Edward had learnt from another woman Mary was living as Charles's wife and they had a daughter but had yet to confront her about the matter. His comrades believed this discovery had been a rude awakening and collapsed his hopes of a happy married life with her, maddening him beyond control. As a soldier, Edward had an outstanding record. He had served for eight years, was an excellent comrade and bore the best of army characteristics and was the adjutant's batman.

Upon his body was evidence that the incident had been a premeditated and cold-bloodied act, committed in a fit of despair and out of jealousy and love. In the left breast pocket of his tunic wrapped around a photograph of Mary was a letter addressed to his brother that read:

Dear George,
This is my last message. The things of mine that you got, you can keep. Gunner Mansfield has my chain and my mother's chain. He will give you my clothes, I don't care what you do with them. Also, 14s and 6d from Harry Brown which will help to pay expenses. Forgive me for this rash act of mine but really, I could not bear it any longer. I take the girl I love with me. God bless her.
 Fred Woodward.

Changing pens, he continued, in red ink, 'let us be buried together'.

Following their deliberations, the jury took just moments to reach and return their unanimous verdict of murder-suicide against Edward.

3. ROBBERS AND BANDITS

Section Eight of the Theft Act 1968 defines the offence of Robbery as 'A person is guilty of robbery if he steals, and immediately before or at the time of doing so, and in order to do so, uses force on any person or puts or seeks to put any person in fear of being then and there subjected to force.'

Lawmakers introduced robbery as a criminal act punishable by death or mutilation during the reign of King Henry II. It remained a capital offence until the 1830s, when the number of capital crimes was reduced. The last executions in England for robbery took place at Shrewsbury on 13 August 1836.

The old Portsmouth to London Road (today the A3) ran for 71 miles, enabling carriages to carry valuable cargos and passengers at high speeds, covering 8 miles an hour. Fear of highwaymen caused passengers to hide money in their boots, sow watches into the lining of their hats and stash other valuables in body cavities, in the often-vain hope that a mounted bandit, bristling with weapons, might be too unpractised or in such a hurry to think to look in less obvious hiding places.

But highwaymen did not always have it their own way. On 13 February 1763, a passenger onboard a Portsmouth-bound coach north of the city, realising the danger, quickly discharged his pistol into a highwayman attempting to rob the occupants, shooting him dead. In 1775, the infamous highwayman Thomas

'Stand and Deliver'.

The Mail Coach.

'Stand and Deliver'.

Not all highwaymen got their own way.

Boulter was operating out of Portsmouth, and for some time went about his business with outstanding success. During the visit of King George III in May 1778, the press reported that he made a 'great harvest'. But his luck ran out soon after, when following a robbery in Portsmouth, an army officer captured him, and he was hanged at Winchester on 4 August.

NICOLAS FINLEY: 'I CAN DO THE SENTENCE AS WELL AS ANY'.

A heart-wrenching and unusual case was heard at the Portsmouth Police Court on 27 January 1890, when Nicholas Finley was tried and convicted of robbery.

For two years the streets of Southsea had been the hunting ground for a predatory offender and notorious footpad, who the press dubbed the 'Youthful Highwayman'. Nicholas was not an opportunist highwayman of centuries gone by; he was a cold and calculating villain who stalked his victims, only attacking when certain there was something worth stealing. He would often attack his victims several times in quick succession, using violence not only to steal, but to secure his victim's silence by making them fear for their lives.

Nicholas's reign of terror ended when Police Constable Bulbeck arrested him and brought him before justices Captain McCoy and Major Greetham. At court, Mr Fisk, the deputy clerk to the court, read out two charges. They were that on 18 January he did, with violence, steal 5s 11d from Thomas Broom, twelve, in Florence Road, Southsea, and on 22 January stole 6d from Alfred Harwood, sixteen, in Saxe Weimar Road, Southsea.

As the constable read the charges, Nicholas stood resolute in the dock, and showed no emotion while confirming that he lived at No. 13 Oxford Road, Southsea, and was fourteen.

No. 2 Clarendon Road today. (RD)

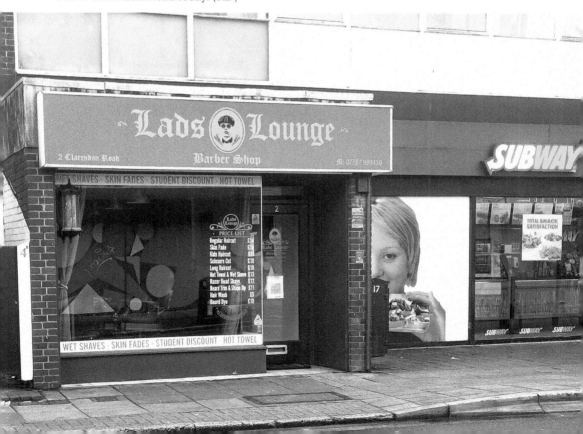

Mr Hedger, a florist at No. 2 Clarendon Road, employed Nicolas's first victim, Thomas, to drive a cart and deliver flowers. On 18 January, Thomas made a delivery at Eton Lodge, receiving payment of 2s 9d. While at the lodge, Thomas spotted Nicholas watching him. As he drove the cart from the lodge onto Florence Road, he observed Nicholas following him at a distance. He saw him again later, watching him delivering flowers to Castlemead House, where he received a payment of 3s 2d.

Around midday, as Thomas left Castlemead House, Nicholas approached waving a knotted rope and caused him to stop. While swinging the rope, Nicholas stated he was going to the tournament, and he wanted money. Thomas said he couldn't give him any money, to which Nicholas replied, 'If you don't hand over the money you have, I will do for you and will murder you when I get you around the corner'. Thomas repeated he didn't have any money, causing Nicholas to shout, 'You have'. Thomas told him that the money he had was not his.

Now enraged, Nicholas punched Thomas in the face, knocking him off the cart onto the ground, where he kicked him hard in the side and shouted, 'I mean to have it – I must have it some way'. Nicholas produced a sailor's clasp knife from his pocket, and as he opened it, stood over Thomas saying, 'I will rip you up with it if you don't give it to me'. Frightened, Thomas surrendered the money and before he left, Nicholas told Thomas he wanted more money next time. Thomas told the court that Nicholas followed him for a while to see where he was going and then headed off in the tournament's direction.

Naval clasp type used by Nicolas Finley.

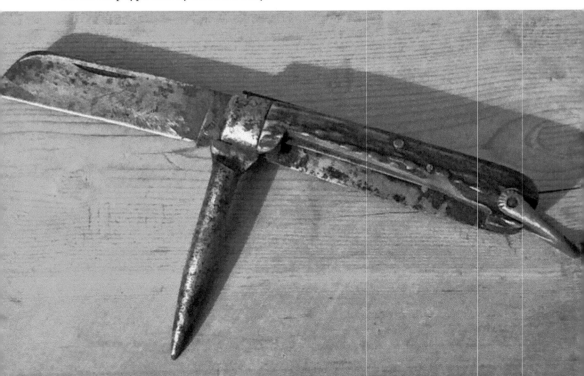

Thomas confirmed to Mr Fisk the money stolen by Nicholas was payment from the sale of flowers he had delivered and belonged to Mr Hedger. Noticing Thomas's comment that Nicholas had said 'next time', Mr Fiske asked Thomas if this had happened before, and if so, how many times? Thomas replied that this was the fourteenth time during the last eighteen months that Nicholas had attacked and beaten him. Mr Fiske asked whether money had been stolen before and, if so, how much. Thomas confirmed Nicholas had stolen £5 of his employer's money. He added he had told his mother what was happening, and she had paid back the missing monies to Mr Hedger.

Thomas's mother testified that her son had made dreadful complaints to her about Nicholas during the last three months, and that on 18 January, he seemed quite ill. She confirmed that then, as a result, she sent 2s 9d to Mr Hedger and on the Monday; she sent a further 3s 2d to him. Mr Fisk asked if she had made up short falls before and, if so, how much? She replied yes, several pounds, but she could not say exactly how many.

Witnesses confirmed they had made the relevant payments to Thomas on the day of the robberies. The housekeeper at Eton Lodge said she had seen the accused with Thomas several times and thought he was helping him. On one occasion, she said Nicholas had called at the lodge to enquire if Thomas had delivered any flowers yet.

Albert Harwood, who also worked for Mr Hedger, said that on 22 January he had received 6d from the cook at No. 30 Clarendon Road for his master. He added, he was driving the cart along Saxe Weimar Road, Southsea (renamed Waverley Road, during the First World War, because of its German connections), when Nicholas approached waving his knotted rope and said to him, 'Have you got any money you devil?' Albert told him he had 6d, at which point Nicholas attacked him, threw him to the ground, reached into his pocket and removed the money.

Albert confirmed he didn't know Nicholas but had occasion to speak to him once and that there was nobody about when Nicholas attacked him. Nicholas, agitated, interjected proceedings, stood up and admitted he was guilty of possessing the money, but didn't know where it had come from and claimed he'd never done it before. He then demanded to be sentenced.

Mr Fisk asked Chief Constable Alfred William Cosser if he had anything to add. He stated he had received many similar complaints against Nicholas but getting witnesses to give evidence had proved difficult.

In summing up, Captain McCoy said that prior to this case, had anyone said that a child just over thirteen had behaved in the way Nicholas had, he would have said 'Could it be true?' He added they had never heard a case of this type since the courthouse had been built. The court found Nicholas guilty of all charges and he was sentenced to fourteen days of hard labour at Kingston prison, then five years in a reformatory. Nicholas was escorted away and as he swaggered past the bench, he stopped, grinned and said to the magistrates, 'I can do the sentence as well as any'.

Left: No. 30 Clarendon Road. (RD)

Below: Waverley Road sign. (RD)

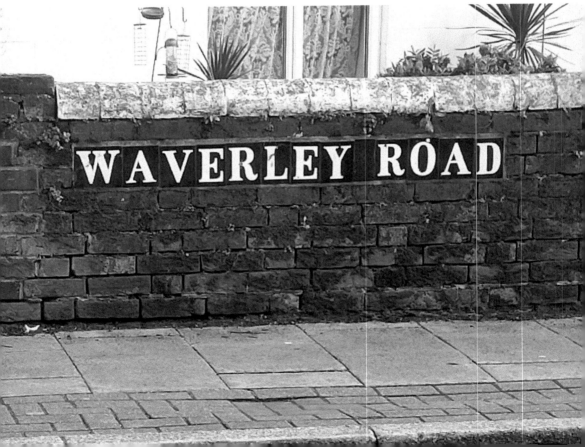

It is said history repeats itself, in this instance many times. There's no better evidence of this than the headline that appeared in local papers on 28 July 1993. 'Child Highwaymen. A gang of weapon wielding children staged highwayman-style hold ups to gain sweet money'. The young gang armed themselves with a baseball bat, penknife, and fake rifle and threatened three lone women in separate incidents across the town.

WILLIAM ALBERT BILLING: 'SOME OF THE BEST BRAINS IN THE COUNTRY'.

With the advent of the motor vehicle, it was only a matter of time before a new criminal threat appeared. So it was during the 1920s and 1930s that 'Motor Bandit's' replaced highwayman and their automobiles the trusty steed of yester year. In Portsmouth, the scourge of the 'Motor Bandit' arrived on 25 April 1932. A gang of seasoned London criminals executed a sensational daylight raid and netted a record bank haul that sparked off a nationwide manhunt.

The planning had been impeccable; the preparation immaculate. Weeks of surveillance had revealed that two members of Lloyds Bank, left the branch in Commercial Road, twice a day and walked the same short distance to the Post Office, where they would deposit the morning and afternoon takings, sometimes as much as £70,000.

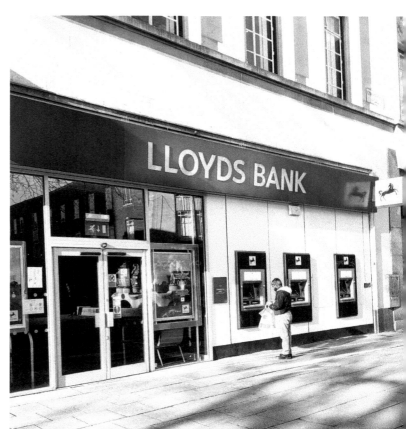

Lloyds Bank, Commercial Road. (RD)

Those performing the surveillance went unnoticed and took no further part in the crime. The week before the raid, others stole a motor vehicle from a London businessman visiting Portsmouth and hid it in the outskirts of the town. They too took no further part in the crime.

At 4pm Mr Snook, a bank clerk, along with Mr Poor, a sixty-four-year-old bank messenger, and a former police officer. Mr Poor was carrying a small canvas bag over his shoulder containing £23,477 (today £1,756,548.) In £1 and £10 notes.

Unaware they were being targeted, they trudged on. Having reached the junction of Edinburgh Road and Commercial Road, just outside the Central Hotel (where for many years Mr Poor had performed point duty directing traffic) a large open top blue and black Chrysler touring vehicle containing four men wearing dark boiler suits and black caps screeched to a halt beside them.

Two men sprang from the vehicle onto the footpath and attacked the bank officials. They knocked Mr Snook unconscious, and hit Mr Poor in the face with

Junction of Edinburgh Road and Commercial Road, 1936.

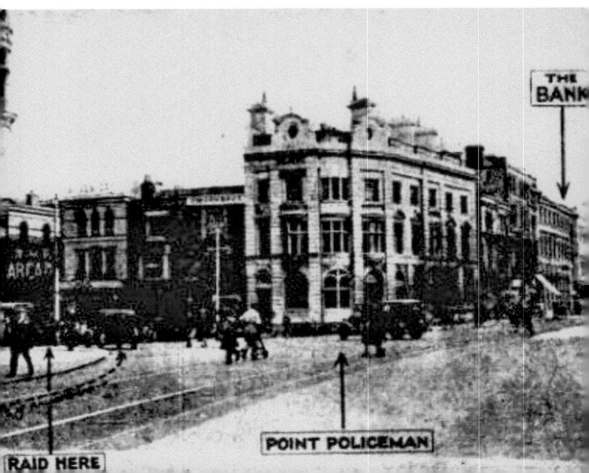

Junction of Edinburgh Road and
Commercial Road today. (RD)

a cosh, and tore the bag from his grasp. Both attackers sprang back into the
vehicle, and it pulled away. Mr Poor jumped onto the vehicle's running board and
attempted to grab the steering wheel. The driver swerved violently but Mr Poor
held on as the car sped up away. The thieves beat him about the head and after
sixty yards having been hit with a life jacket Mr Poor was thrown from the vehicle
at a speed estimated between 50–55 mph, landing in the gutter unconscious and
badly hurt.

The vehicle sped off, pursued by an elderly resident on a motorbike and local
lorry driver. Another sign of the gang's preparation was their escape route.
Instead of travelling along Commercial Road, the busiest thoroughfare in the
city or towards Southsea, they sped down the quiet Edinburgh Road pursued
along Anglesey Road, Park Road and Portsea Hard towards the Dockyard. At
the entrance to the Vernon Shore establishment, Gunwharf, they disappeared, but
not before the motor cyclist had noted the number plate, HC5 171.

Ambulance and police were soon on the scene. Mr Pool was taken to the Royal
Hospital. Mr Snook, with a gash across the bridge of his nose, returned to the
bank and went home to receive medical treatment. The chief constable mobilised
Portsmouth Police's Flying Squad to scour the district while uniformed officers
set up cordons on the city's outskirts.

Metropolitan Police, Dockyard Division, Portsmouth.

When a member of the public reported seeing the getaway car speeding northbound towards London, it was thought the 'Auto Bandits' had out manoeuvred the police. Messages were sent to Scotland Yard who immediately dispatched their Flying Squad cars to the South-West District of London.

Surrounding forces increased patrols on key roads, while local police spent all night searching the Portsea area, stopping cars and people to no avail. In the days that followed, police appealed for witnesses and asked residents to check garages and report anything unusual to Lloyds Bank, who were offering a reward of £3,000 (today £211,000) for information. The audacious crime was dubbed 'The Great Portsmouth Bank Note Robbery' and spurred a nationwide manhunt. Staff released Mr Poor from the hospital in early June, unable to recall anything that happened before they hit him in the face.

Following an investigation by Portsmouth's Criminal Investigation Department, and the Metropolitan Police's Flying Squad, on 2 May, police made two arrests in London. When their getaway car was discovered in a lock-up garage in Elmgrove, Southsea, on 6 June, the net tightened, and a third arrest followed. Within a month, three of the four-man gang, John Parker, 48, a painter, Alfred Hinds, forty-three, a furniture dealer, and Benjamin John Bennett, 30, a motor mechanic, all from London, had been arrested and charged.

On 8 July, at the Winchester Assizes, all three suspects entered not guilty pleas. During a trial that lasted three days, the prosecution case alleged Parker had been responsible for the assaults on Snook and Poor. Hinds had transferred the cash from the canvas bag to another bag, which he took back to a house in Unicorn Road in Landport, where he and the fourth outstanding offender took lodgings on the morning of the attack. There, having changed his clothes, Hinds left with

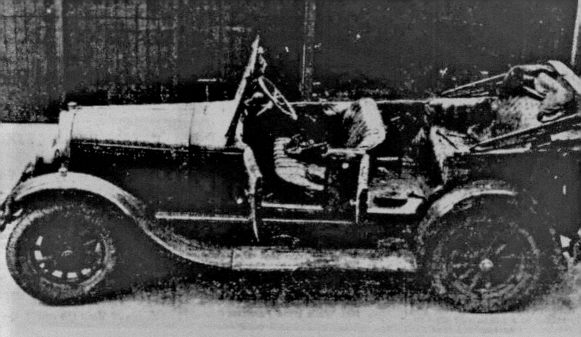

The Chrysler motor-car, H.C. 5171, which figured in the raid. In the car can be seen three caps and a suit of overalls. Lying on the back seat can be seen a jack handle and on the floor a hammer

The getaway vehicle.

the bag and wasn't seen again until his arrest. Bennett had driven the vehicle and hid it at Elmgrove before returning to London, where he was arrested the following day for an unconnected robbery.

Officers told the judge that Parker and Hinds had served previous terms of penal servitude and that Parker associated with notorious thieves in London and they suspected him of being involved in smash and grab raids, burglaries with violence and other crimes. They believed Parker was the gang's leader, a man of violence who would stop at nothing to commit crime or escape capture. They added Hinds was also known to associate with skilled thieves and criminals. Officers concluded Bennett was an expert driver and suspected of driving in several smash and grab raids and serving a term of imprisonment for robbery.

The Judge said that he couldn't imagine a worse case of its kind, or one more meticulously planned and commented that no penny of the stolen £23,477 had been recovered. At the conclusion of the trial, the jury took just thirty-five minutes to return a guilty verdict.

The Judge sentenced Parker to fifteen strokes of the Cat-o'-nine-tails and five years penal servitude; Hinds got fifteen strokes and four years penal servitude, and Bennett fifteen strokes and three years penal servitude.

In May 1932, William Albert Billing, the Lord Mayor of Portsmouth addressed a police superintendent's conference in Portsmouth about 'Motor Bandits'. He said that the police were up against some of the best brains in the country and added that if they had turned their attentions to benefit the State, it would be far better off.

4. WITCH TRIALS – FRAUD AND DECEPTION

HELEN DUNCAN: 'OH GOD, IS THERE A GOD'

Helen Duncan, or as the press dubbed her 'Hellish Nell', was a self-proclaimed spiritualist and medium who specialised in the materialisations of spirits. In 1944, she became the first person in the UK in 100 years to be tried, convicted and sentenced to prison under the Witchcraft Act of 1735.

Throughout the 1920s, 1930s and 1940s, Duncan held seances at hundreds of Spiritualist churches and home circles across Britain. During these she allegedly produced the spirits of dead people by emitting ectoplasm from her nose and mouth, which communicated with and touched her audiences.

Helen Duncan

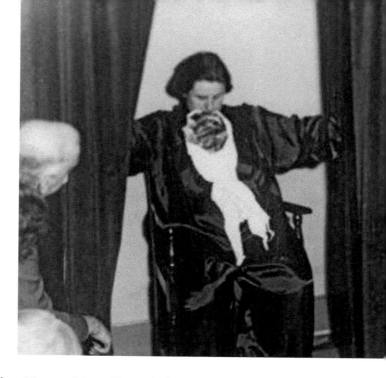

Duncan emitting
ectoplasm, 1928.

In 1928, photographer Harvey Metcalfe took flash photos during one of Duncan's seances, revealing the conjured spirits to be papier-mâché masks draped with an old sheet. In 1931, at the invitation of the London Spiritualist Alliance, Harry Price, psychic researcher and fraud buster, investigated Duncan's performance. Having examined samples of ectoplasm produced during her seances, he revealed them to be regurgitated cheesecloth and paper stuck together with egg whites, and at one sitting he proved a 'materialised hand' was nothing more than a rubber glove.

In 1933, an audience member grabbed a manifestation calling itself 'Peggy' from the side of Duncan's skirt, revealing it to be a stockinette undervest. Duncan was arrested, charged, convicted and ordered to pay a £10 fine. However, despite such revelations, her popularity endured.

The Portsmouth Temple Psychic Centre was registered as a Spiritualist church, operating from above Homer's druggists at No. 301 Copnor Road, Portsmouth. In January 1941, it advertised its meetings in the local press. However, the meetings conducted by Duncan were not advertised, but word of mouth led to these fee-paying events being held in private. This made the police, navy and security services sit up and pay her even more attention.

During a seance in Edinburgh on 24 May 1941, at 3.30 p.m. Duncan announced that HMS *Hood* had been sunk earlier that day in the North Atlantic. In the audience was Brigadier Firebrace, a fervent believer in spiritualism and chief of security in Scotland. Firebrace telephoned the Admiralty to see if a 'rumour' of the sinking was true. They denied it. At 9.30 p.m., he received a telephone call from the Admiralty confirming the sinking had happened at 1.30 p.m.

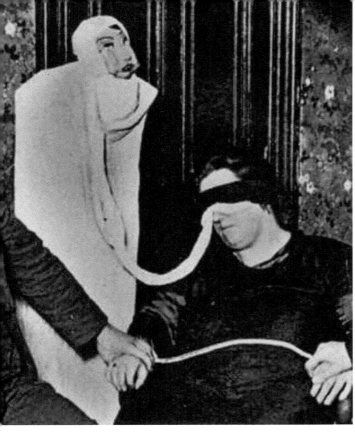

Left: Spirit revealed as papier-mâché masks.

Below: Portsmouth Temple Psychic Centre.

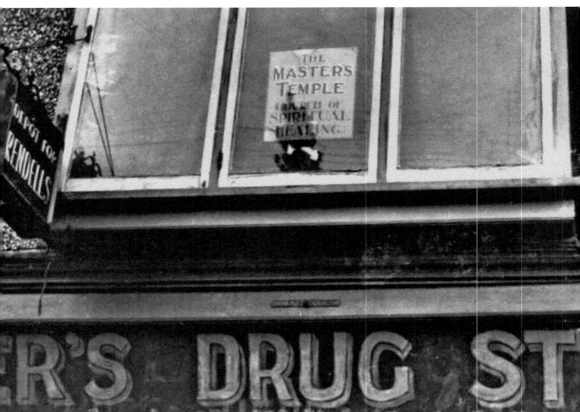

No. 301 Copnor Road today. (RD)

Six months later, police received reports that during a seance Duncan had summoned the spirit of a sailor, wearing a hatband marked HMS *Barham*, who claimed he was one of over 800 men to die when a German U-boat torpedoed the ship. Those present were shocked, as there had been no mention of the disaster, although HMS *Barham* had actually been sunk on 25 November 1941.

Another lucky guess! Leaked information? Or a genuine paranormal phenomenon? Irrespective, the British government and the Royal Navy wanted to know how Duncan came to be in possession of classified military information. Was she spying for Germany? Did she have an informant in the War Office?

On 14 January 1944, two navy lieutenants, Worth and Fowler, were among Duncan's audience. They had previously met Francis Brown, Duncan's agent, who showed them images she said were genuine spirit photographs and asked them if they wanted to meet Mrs Duncan.

During Duncan's show, a white clothed figure appeared, claiming to be the aunt of one of the lieutenants, although he had no deceased aunt. Another figure appeared in the same sitting, claiming to be his sister, who was alive and well. Incensed by what they felt was a blatant act of fraud and deception, they reported Duncan to the police.

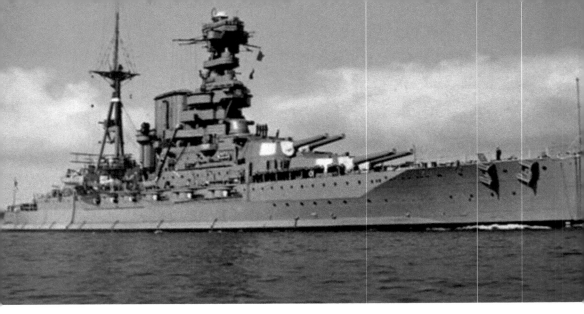

HMS *Barham*, 1941.

Duncan held another seance on 19 January, but the twenty-person audience included an undercover police officer. When a white-shrouded manifestation appeared, Police Constable Cross pulled the shroud off to reveal Duncan beneath. He alerted officers waiting nearby, but 'confederates' whisked away the shroud and other items in the room before they arrived.

Duncan, along with Ernest Homer and Elizabeth Jones (aka Homer), operators of the Psychic centre, and Frances Brown, who travelled with her, were arrested under section 4 of the Vagrancy Act of 1824. This minor offence states that 'Every person pretending or professing to tell fortunes, or using any subtle craft, means or device, by palmistry or otherwise, to deceive and impose on any of His Majesty's subjects shall be deemed a rogue and vagabond, liable to trial in a magistrates' court and, on conviction, to imprisonment with hard labour for a period not exceeding three months'.

Police found a fake HMS *Barnham* hat band during a search of Duncan's Portsmouth address. Post-1939, for security sailor's hatbands only carried the initials HMS. Duncan was charged under section 4 of the Vagrancy Act 1824. She was also charged with 'conspiracy to cheat and defraud by pretending that at seances promoted by Homer and others she was capable of holding communications with the spirits of deceased persons and causing them to materialise'. Further searches produced a quantity of photographs showing images of manifested spirits taken at seances.

The police also charged Homer, Jones and Brown with 'conspiring with Duncan to cheat and defraud, by pretending that at seances promoted by them, Duncan was capable of holding communications with deceased persons'.

Duncan was remanded in custody to attend Portsmouth Police Court on 29 February; Homer, Jones and Brown were released on bail to the same hearing. With a maximum of six months' imprisonment, the authorities thought the case

PC Cross.

was too serious to be dealt with summarily, and recharged all four with offences in contravention of section 4 of the Witchcraft Act 1735, which stated that 'any person who may pretend to exercise or use any kind of witchcraft, sorcery, enchantment or conjuration, shall be liable on conviction to a maximum year's imprisonment'.

The Police Court hearing was brief. All four confirmed their names, addresses and pleaded not guilty. Duncan was remanded in custody to appear on 23 March, at the Old Bailey, London. Homer, Jones and Brown were bailed to the same hearing.

The case lasted seven days, during which sizeable crowds, hoping to hear the case, queued for over two hours, and packed out the court precincts. Duncan offered to show her ability. The judge rejected the request, stating such a demonstration 'might operate unfairly against this woman because, supposing the spirit, if such a thing there be, was not mindful to come to her assistance on this occasion, then the verdict would have to be against her'.

Despite the lack of material evidence from the seance, the police photographers provided enough evidence to prove Brown's photographs were fakes, and the jury found all four guilty of witchcraft.

Portsmouth's Chief Constable Arthur Charles West stated the Homers were people of good character, but Brown had two convictions for shoplifting. Duncan

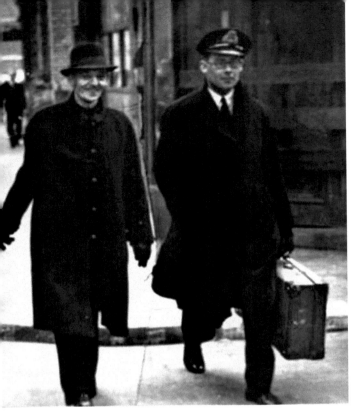

Lieutenant R. Worth and PC
Cross arriving at Old Bailey.

Helen Duncan outside Old
Bailey.

had been previously charged with fraud and was on police bail for announcing the loss of a warship before the news should have been made public. He concluded he could find no redeeming feature in her character.

Passing sentence, the judge said, 'As the jury have found this to be a case of plain dishonesty, I can make no distinction between the accused and others who are convicted'. He said that as Duncan had made most money out of the fraud, she should go to prison for nine months. Duncan collapsed crying, 'Oh, I have done nothing'. 'Oh God, is there a god'. She was then carried down to the cells.

Because Brown aggravated her offence by producing fake spirit photographs, the judge imprisoned her for four months. The Homers were more fortunate. He accused them of allowing their enthusiasm to close their eyes to what was going on and bound them over for two years. All four launched an appeal, which was rejected. In 1951 the 1735 Witchcraft Act was repealed, replaced by the Fraudulent Mediums Act – but too late for 'Hellish Nell'.

The Fraudulent Mediums Act 1951 prohibited a person from claiming to be a psychic, medium or other spiritualist while attempting to deceive and to make money from the deception (other than solely for the purpose of entertainment). This was also repealed on 26 May 2008 by Schedule 4 of the Consumer Protection from Unfair Trading Regulations 2008.

5. MURDER MOST FOUL

PHILLIP MATTHEWS: 'I HOLD OUT NO MERCY FOR
YOU IN THIS WORLD'

The hanging of Phillip Matthews thirty-two, a coachman from Teignmouth, Devon, was the last of its kind to be held in Britain. Triple executions were considered too cruel, as condemned prisoners often fainted during the wait, only to be woken and made to wait again because of the time taken to place the ropes around their necks.

On Tuesday 21 July 1896, Matthews awoke at 6.30 a.m. from a sound night's sleep. Following a hearty breakfast, he sat on his bed in silent contemplation with only a chaplain and prison warden for company. A few moments before eight, the sound of metal turning metal, followed by a shuddering clank. Matthews' cell door opened, and the executioner's assistant, William Warbrick, strode through in silence.

Raising Mathews to his feet, he placed his wrists behind his back and Warbrick secured them with a double buckle leather strap. He placed another strap around Matthew's ankles before placing him in the corridor, where he waited. He watched Warbrick enter two more cells and heard him repeat the process, before instructing all three men and their warders to move forward. In silence, they shuffled the short distance to the gallows.

Entering the execution room, the condemned strangers Matthews, Smith and Burdens saw the executioner, James Billington, and other officials and three nooses dangling above trap doors marked in chalk with their initial. Warbrick placed each man upon his trap; Billington approached each man and placed a cotton hood over his head, arranged the noose around each neck, and pulled it tight.

With the last noose in place, he stepped aside, pulled the leaver and sent three men to their death. The complete process from cell to drop took two minutes. Matthews and Smith died immediately. Burden's body jerked for a moment or so as he fought to survive. Afterwards, a black flag was flown above the main prison gate, signalling the deed was done.

Matthews had been condemned for the murder of his six-year-old daughter, Elsie Gertrude Matthews, whose body had been found discarded under a hedge, beside a field, near the Copnor railway crossing (replaced by a bridge in 1908) on 7 April 1896. A crime that shocked and saddened the residents of Copnor, the surrounding areas, and the region.

Following Mathews arrest by police on 9 April, he was charged with Elsie's murder, and rumours circulated he had left his wife and murdered Elsie to marry

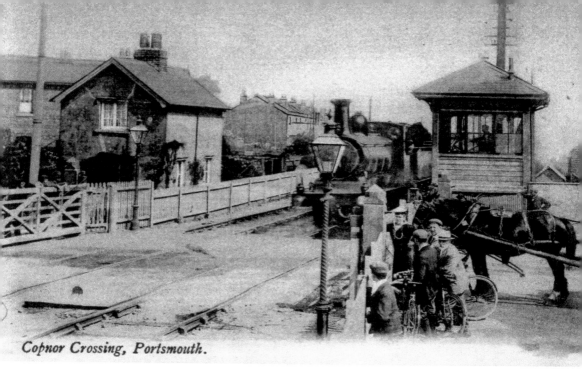

Copnor Crossing, Portsmouth.

Copnor railway crossing, 1905.

Charlotte Maloney, a parlour maid from Kingston. Sensing a growing swell of unrest within the community against Mathews and Maloney, the police sought to keep Elsie's funeral as private as possible.

Feelings and emotions continued to run high in the days leading up to Elsie's funeral, despite Matthews being in custody, and when that day came, mourners gathered in large numbers, lining the thoroughfares along the route from the mortuary, where Elsie's coffin had laid overnight, to Kingston Cemetery.

In response, the police drafted in extra officers, restricted access to the cemetery and locked the gates. Detectives mingled among the crowd, but police numbers were no match for the size of the gathering, which had swelled throughout the day to over 10,000. By comparison, the population of Copnor in 2011 was 13,608.

For safety reasons, the police reopened the gates, and several thousand mourners followed the procession behind the hearse, conveying Elsie's body into to the cemetery. She was encased in a small elm coffin, to which was attached a breastplate that bore her name, and the lines, 'There's a home for little children, above the bright blue sky'. The coffin was covered with white cloth, upon which a small bunch of yellow daffodils had been placed along with a few Lent lilies.

During the graveside service, performed by Revd F. Wallington, several mourners broke down and collapsed. A rumour swept through the crowd that Matthews' lover, Charlotte Maloney, was in the cemetery in disguise, having arrived from her home in Kingston in a handsome cab ahead of the cortege. A large angry crowd headed towards her address and waited for her return.

Above: Kingston Cemetery Chapel.

Below: Kingston Cemetery.

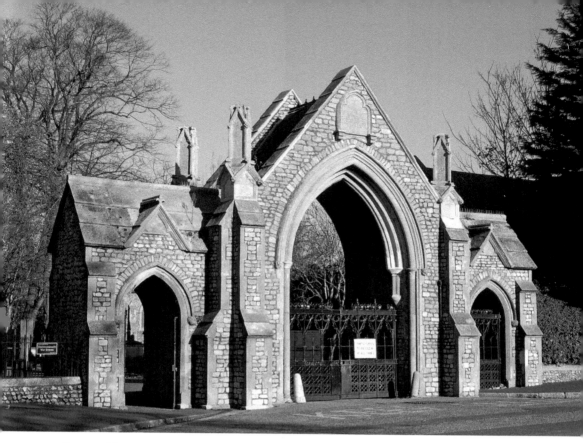

Gates to Kingston Cemetery.

At the conclusion of the service, with emotions still highly charged, thousands of mourners queued to throw flowers into the grave. The crowd mistakenly identified a young American woman visiting the cemetery, Mrs Adelaide Prout, for Charlotte Maloney.

A shout went up, 'There she is', and a large angry mob rushed towards her, fiercely pursuing her through the cemetery. She was cornered; they began stoning her as an adulterer and then set about beating her with umbrellas and sticks. When she fell over, the crowd began trampling on her and she might have been the victim of a tragic murder herself had it not been for the swift action of the detectives amongst the crowd. They rescued her from the clutches of the violent mob and got her to the safety of the Registrar's Office, which remained besieged for two hours before the police could disperse the crowd.

Maloney had been at the cemetery but, fearing the crowd, left. She was too quick for the mob and got home and inside unscathed.

An inquest held on 10 April at Portsmouth Town Hall established that Elsie's death had been caused by strangulation by throttling. When cautioned, Matthews initially denied murdering his daughter, stating she died from fright caused by dogs barking, but later admitted her murder before changing his account several more times.

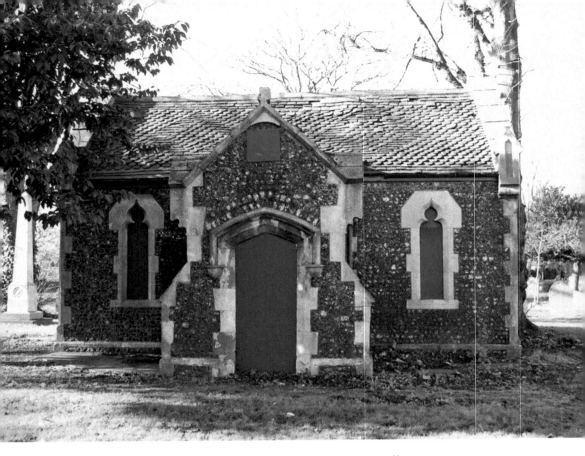

Above: Former Registrar's Office.

Left: Artist's impression of Maloney leaving the cemetery.

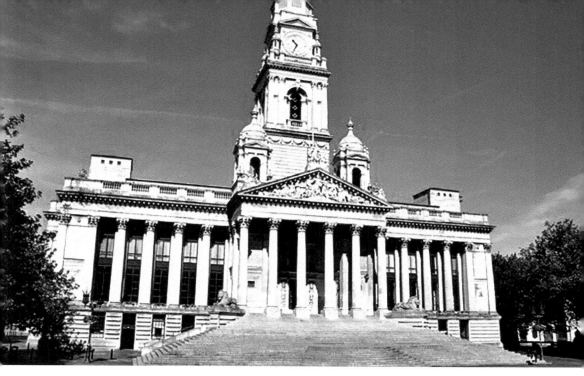

Portsmouth Town Hall. (Stuart Gunn, cc-by-sa/2.0)

Matthews' wife, Maria, gave evidence that Elsie's mother, Elizabeth Matthews, had died in 1892, and later that year she had married Phillip Matthews, who she had known for several years. Maria stated that during their marriage, Matthews told her he had a wife whom he had not divorced before marrying Elizabeth.

She added they hadn't lived happily together. For the last twelve months, they had quarrelled frequently about Charlotte Maloney, a parlour maid from Portsmouth, working in Teignmouth, who he admitted he was planning to marry.

Maria told Matthews that if he left her, she would no longer look after Elsie and he would have to care for the child, and that he had better sort the situation out before the end of the Easter weekend or she would make trouble for him. This was a problem for Matthews, as Maloney, who had just discovered she was pregnant, had said she would not marry him if it involved looking after another woman's child.

Matthews told Maria he was leaving and taking Elsie with him. Maria packed a few things for Elsie and accompanied them to Teignmouth railway station. The last time she saw Matthews was when he left with Elsie on Easter Monday, 5 April. When asked what he was intending to do, he said, 'I'm taking Elsie to London. I'm going to take her where she will be better taken care of, better than she has been'. The following morning, Maria received a telegram announcing their safe arrival in London; however, her suspicion was aroused as the message had been sent from Botley, near Portsmouth.

On 7 April, she received a letter from Matthews, also bearing the Botley postmark. She described its contents as extraordinary and incoherent. He said he would never hope to bear his good name again, and that he had left Elsie looking so happy. It ended, 'may you and Elsie be happy'.

Next to give evidence was Charlotte Maloney. In an intense and hostile atmosphere, she confirmed that she was in an intimate relationship with Mathews and had told him that she would not look after another woman's child. She said they were to be married and that on 3 April, they had left Teignmouth and returned to Portsmouth. There, she introduced Matthews to her mother as her future husband, not believing or knowing he wasn't legally separated.

The jury took just twenty minutes to return their verdict of wilful murder and the coroner remanded Matthews in custody until his trial at the next Winchester Assizes.

On 26 June, at Winchester Assizes, Matthews, despite previous admissions of guilt, entered a not guilty plea. His defence was that they had slept rough on the 6 April, and that having fallen asleep, he rolled onto Elsie, and accidentally smothered her. Realising his mistake and fearing no one would believe him, he panicked, dumped her body and attempted to continue as normal. However,

Condemned prisoner in cell.

the medical evidence submitted by the prosecution refuted his defence as an impossibility and showed that Elsie's neck bore the injuries of being choked, not smothered.

Having heard the evidence, the jury retired and reached a verdict of guilty in just seventeen minutes. This was met with rapacious applause from the public gallery, and the sound rippled throughout the crowds gathered outside the courthouse.

The judge placed a square of black silk upon his head, looked at Matthews and said, 'Phillip Matthews, you will be taken hence to the prison in which you were last confined and from there to a place of execution, where you will be hanged by the neck until you are dead and thereafter your body buried within the precincts of the prison and may the Lord have mercy upon your soul.' He added, 'I hold out no mercy for you in this world'. Matthews replied, 'I am innocent'.

Mathews was returned to Winchester gaol and placed in a condemned cell close to the gallows. There, whilst awaiting execution, he was described by a warder as 'a most romantic murderer who talked about love and women, and his prospect of going to heaven after his death'. He all but exhausted the prison's stock of paper writing poems to Maloney, who visited. Matthews was so infatuated by her that the warden believed there was nothing he would not do for her.

MAURICE ERNEST BEVIS: 'YOU WOULDN'T THINK THESE DID IT WOULD YOU?'

The Bevis family were pleasant, unassuming and well liked in the community. Alfred, fifty-seven, was a dockyard foreman and his son Maurice, sixteen, an apprentice in the same department. They were conscientious, punctual and never failed to turn up for work.

At 12 p.m. on Monday 17 January 1938, Victor Heath, a shipwright in the dockyard, a friend and neighbour of the Bevis family, called at their home, No. 42 St Chads Avenue, North End. He wanted to enquire after Alfred and Maurice, who had not turned up for work that morning.

Arriving at the Victorian three-bedroom terraced house, Victor saw the downstairs curtains drawn. The day's milk was beside the door and the wireless played louder than normal. Victor rang the doorbell but received no reply. Having asked neighbours if they had seen the Bevis family, Victor assisted neighbour Andrew Baker, a sergeant in the Royal Army Ordnance Corps, to climb into the Bevis's rear garden. Receiving no response to his calls, Andrew entered the house via a glass lean to, and made his way through the hall to the front door and let Victor in.

Calling out, the two men entered the living room and were concerned to see ransacked cupboards and drawers. Next, they entered the dining room, where they made a most gruesome discovery. Sitting upright in an armchair, covered with a green blood-soaked tablecloth with only his lower legs visible, was what looked like Alfred's body. Shocked, the men left and called the police. When

No. 42 St Chads Avenue. (RD)

Sergeant Hatchet arrived, the men told him what they had discovered, and he entered the premises and began searching the house, room by room, floor by floor. Downstairs, he saw drawers and cupboards had been untidily searched. Moving upstairs, he found further evidence of frenzied searching in the bedrooms and in the front bedroom he found a wallet and two purses on the bed, all open and empty, but no trace of Alfred's wife Matilda or Maurice.

The last room he checked was the bathroom. Inside, to his horror, he saw walls splattered with blood. In the bath lay a naked, bloodied and battered body, with the head covered by a bloodstained towel. Hatchet pulled back the towel to reveal the face of the victim. It was Matilda, her skull smashed in several places and covered in congealed blood. On the floor, amongst her under garments, lay a bloodstained axe.

Both Alfred and Matilda had received several blows to the head from a heavy blunt object and, on closer examination, Alfred also had eighteen puncture wounds in his chest. Following a medical examination of the bodies at the scene and an assessment of the house, the police estimated the time of death between 12 p.m. and 6 p.m. the previous day. There was no doubt the Bevis's had been murdered, but where was Maurice?

Hatchett type used by Maurice.

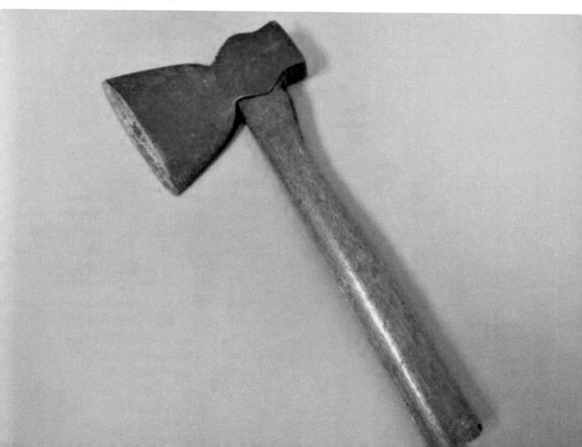

Maurice's absence and a lack of a motive for his being abducted made him the police's number one suspect. The senior investigating officer appointed was Superintendent Turner, Chief of Portsmouth Criminal Investigative Department. Despite every effort and resource focussed on locating Maurice by the end of the day, he was still at large.

Enquiries continued the following day, and the search widened with investigations pursued across the home counties. At 5.30 p.m. Detective Sergeant George Miller was at his desk in Scotland Yard, London, when the desk sergeant requested his attendance at the front counter.

Upon his arrival, he met a young male who said to him, 'I want to make a statement'. Showing him a copy of the *London Evening* newspaper, he pointed to a story about the man and wife found murdered at Portsmouth. Miller looked quizzically at the person before him, but before he could comment the male held up his hands and added, 'You wouldn't think these did it, would you?' 'I'm Maurice Bevis'. At which point he produced a wallet containing two £5 notes, seven £1 notes, twenty-nine 10s notes and 17s 6d in silver coins. Maurice added, 'This is some of the money belonging to them'. Millar had dealt with many unusual situations in his career, but this was exceptional.

Miller cautioned Maurice, who made a detailed statement to him about what he had done, in which he said, 'Something came over me. I can't explain. For some unknown reason, I got a chopper from the shed. I hit dad over the head with the sharp end. He fell back in the chair. I went upstairs and mother was still in the bathroom. I opened the door. She had her back towards me, and before she could say anything, I hit her on the head two or three times with the sharp end of the chopper and she fell back into the water. I then realised what I had done and dropped the chopper. I threw a cloth over her'.

Maurice then explained how he collected money from various drawers upstairs before he went back downstairs. 'Dad was making a terrible noise, a kind of groaning. I could not bear the noise, so I went to a draw in the kitchen and took out a two-prong carving fork. I stabbed dad twice in the heart through the shirt. He stopped groaning. I threw the fork back in the draw and then threw a tablecloth over him'.

Describing how he left the house, Maurice took a train to Waterloo, London. There having got a taxi to the Regent Palace Hotel, he booked in under a false name arriving between 6 p.m. and 7 p.m. There he booked in under a false name. Maurice then went to the pictures then returned to the hotel but could not sleep. The next day, he went to the Science Museum and afterwards saw the pantomime *Aladdin*. He added, 'When I came out, I bought a newspaper and saw a report of the murder, so I came straight here'.

Miller arrested Maurice and contacted Superintendent Turner, who, having arranged for the recovery of the carving fork, travelled to London to collect the prisoner. Back at Portsmouth, Superintendent Turner charged Maurice with murder, bailing him to appear at Portsmouth Juvenile Court on 27 January.

Carving fork similar to that used by Maurice.

At Portsmouth Juvenile Court, Maurice confirmed his name and address and that he would be seventeen on the 19 February. The charge read stated that on 16 January in Portsmouth Maurice did feloniously, wilfully and of malice of forethought kill and murder Alfred Ernest Bevis and Matilda Sophie Bevis. When asked how he pleaded to the charge, he replied, 'I plead not guilty and reserve my defence. I do not propose to give evidence to-day or to call witnesses'. The court remanded Maurice into custody and committed for trial at Winchester Assizes.

In what would become a strange twist of fate, when Maurice arrived at Winchester, the prosecution had dropped the charge of murdering his mother. He confirmed his not guilty plea to murdering his father, and his barrister added they would offer a defence of insanity. The prosecution presented their case and the defence theirs, during which one jury member fainted twice and had to be replaced.

Defence council asked Victor Heath, who discovered the crime scene, if it were true that Maurice displayed passionate affection for his mother. He replied, 'Oh yes. Quite'.

Dr William Dewey, the Bevis' family doctor, said he knew them well. Mr Bevis was ambitious for his son and sent him to a school where they had little time off and did nothing but work all the time. Having examined Maurice the previous

day, his mental condition appeared normal. But he added that there were cases of adolescent-mania which resulted in sudden homicidal outbreak, and it was possible that at the time of the crime he was experiencing just such a bout.

Dr Grierson, senior medical officer at Brixton Prison, said that there was no history of insanity in the Bevis family. 'He told me that, although he was not unhappy, his mother fussed over him too much, and his father had urged him to pass examinations since his childhood'. Dr Grierson added that when he had asked Maurice about the crime, he told him he knew nothing about it until he found himself stood by the front door with his bag packed and he remembered what he had done.

The prosecutor asked Dr Grierson whether anything he had heard in court satisfied him that the boy was insane when he did this? His reply was simple. 'No'. Dr Smyths, medical officer at Winchester Prison, gave similar evidence.

Superintendent Turner gave evidence that Maurice had attempted suicide by gassing himself on 10 December 1935, at age fourteen, while at Esplanade School. Mr Cain, a schoolmaster, had returned to the school to start the night classes and found Maurice collapsed behind a locked door on a classroom floor suffering from coal gas poisoning.

Maurice's barrister put it to the jury that Maurice was labouring under difficulties by a disease of the mind and was incapable of apprehending the nature and quality of his acts. He said, 'the trouble is the lad was suffering from what was known to medical sciences as adolescent-mania'. He added, 'during the period of early adolescence, the brain sometimes is deranged, and the youth is inflicted with a desire to kill, sometimes himself and sometimes some other. That is the only justifiable explanation for such a deplorable case'.

The judge summed up the evidence and directed the jury to retire to consider their verdict. They took twenty minutes to proclaim Maurice guilty of murder. The judge stated in passing judgment he could not sentence a person under eighteen to death. As a result Maurice would be detained at His Majesty's pleasure in such a place and in such circumstances as the Home Secretary decided appropriate. He added that maybe some mental institution was the best place for him for a time.

On 14 December 1939, Maurice was at the centre of another court case, this time at the High Court, Chancery Division, London. Maurice was defending his right to inherit his mother's estate against a counterclaim from his uncle, Mr Thomas George Bundock. Maurice's solicitor claimed that the police and medical examiner had proved that his mother had been the second victim to die. Thus, she inherited her husband's estate of £3,710 before she died. When she died by her son's hand, her estate, totalling £4,396, should pass to Maurice as the surviving heir.

Thomas contested it would be against public policy for Maurice to benefit from the estate because Maurice murdered his sister. Council for Maurice argued that his confession was inadmissible in civil proceedings. The case would need to be considered afresh. He also gave evidence that Maurice was very passionate about his mother and proud of her.

The court adjourned and reconvened on 6 December where the judge ordered that one third of the estate would be payable to Mr Bundock and two thirds placed in a trust for the benefit of Maurice should he be released.

The Civil Births, Marriage, Death and Parish Records for the UK record only one male named Maurice Ernest Bevis, born in 1921, and it is not known when Maurice was released or what became of him. On 8 August 1949, a male purporting to be Maurice Ernest Bevis, born 1921, boarded the Cunard White Star Ship *Aquitania* at Southampton, bound for Halifax, Canada. Ida Bevis, his wife, accompanied him. Coincidence? Or did Maurice use his ill-gained inheritance to start a new life abroad?

Cunard White Star ship *Aquitania*.

6. ARSON AND MUTINY

JAMES AITKEN: 'I HOPE GOD, IN HIS GREAT MERCY, WILL FORGIVE ME'

On 10 March 1777, a dishevelled red-headed Scotsman took his place in history as his gaoler drew him in chains on a wagon toward the site of his impending execution. A crowd of 20,000 had gathered to witness this momentous occasion and were panting in bloodthirsty expectation.

As the wagon neared the gallows, it passed by the charred ruins of a once immense building in the walled naval store yard. The previous autumn it had bristled with activity, as workers wound and twisted mile upon mile of hempen rope creating rigging and ropes for His Majesty's ships. Such ropes had helped the Royal Navy impose cordons around the ports of rebellious cities in the American colonies. Its loss was the first in a series of attempts to obstruct the navy's ability to impose the king's will upon his unruly subjects across the sea. The first successful terrorist attack on mainland Britain had inflamed the passions of the British people against their American cousins, and they were eager to see justice done.

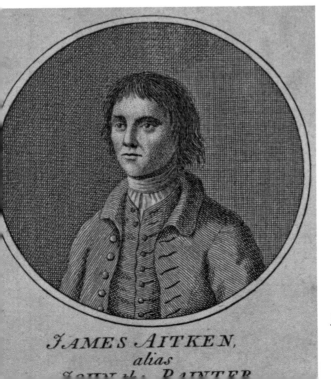

JAMES AITKEN,
alias
~~JOHN the~~ PAINTER

James Aitken.

The Scotsman, born James Aitken, was a house painter by trade. Later, he became a mercenary and saboteur, targeting British naval dockyards during the War of American Independence (1775–83). Born in Edinburgh, in 1752 he became known by the aliases James Boswell, James Hill, James Hinde, John Aitkin and, most infamously, as John the Painter.

Having served out his apprenticeship in Edinburgh, he struggled to find regular employment, so, aged twenty-four, left Edinburgh for London, but there was no work to be had as a painter and criminal activities proved far more lucrative.

He became a highwayman, but having never ridden a horse, had to commit his robberies on foot. He also committed burglaries and shoplifting, and on one occasion he raped a young shepherdess at Basingstoke, Hampshire. His travels took him to many towns and villages across England, and he boasted of having committed a felony in every county.

When his likeness appeared in a newspaper in 1773, Aitken feared the authorities would soon arrest him. To avoid capture, he secured a passage to Jamestown, Virginia, by indenturing himself to the ship's captain for £24. On arriving at Jamestown, the captain sold the indenture to a local businessman. Aitkin had no intention of working off his debt and was soon on the run. Via Maryland and Philadelphia, he arrived in Boston and took part in the tea riots of 1773. In May 1775, he returned to England. Arriving in Liverpool, where he enlisted in the army for the enlistment bonus of 26s, and then deserted, a fraud he repeated twice.

He then made his way to London on a crime spree, burgling shops, houses and committing street robberies along the way. In London, he committed more robberies and burglaries. His activities were drawing a lot of attention and a bounty was offered for his capture. Having fled, he robbed his way through several other counties before joining the army in Colchester and remained in their ranks for several months to hide from those pursuing him.

Aitken was ambitious. He dreamed of becoming an officer, but his social status prevented him. In the colonies he'd developed sympathies for the American Revolutionaries and his hopes turned to a commission in the revolutionary army and set his intentions to supporting their cause.

By sheer chance, he overheard men discussing the war in an alehouse. They agreed that the safety, welfare and existence of Britain depended upon the Royal Navy and its dockyards. This gave Aitken the idea of crippling the Royal Navy by destroying the most important naval buildings in Portsmouth, Plymouth, Chatham, Woolwich and Deptford. He hoped to gain the admiration of the world, the respect of the American Revolutionaries and a commission in the American Revolutionary Army.

Aitken toured the dockyards, making sketches and taking notes, and in the autumn of 1776, he travelled to Paris to discuss his plans with Silas Deane, the American Congress's envoy in France. Aitken explained how he intended to set a series of fires by using a simple firebomb, a candle and a tin box with its base

Boston Tea Party, 1773.

filled with tinder. His ingenuity impressed Deane, and although he thought the plan bordered on madness, promised him a small amount of money, a commission and a contact in London.

In early December, Aitken was in Portsmouth where he planned to set three fires, one in the dockyard and two in residential neighbourhoods. Sneaking into the dockyard, he entered a hemp storage barn to set up one of his devices and soaked a bale of hemp with turpentine and gunpowder. He decided not to light it, as he wanted to see whether he could start an even larger blaze elsewhere. Aitken entered the 1,000-feet-long rope house, where rope was braided from hemp threads into the colossal ropes for the Royal Navy's warships. Having set another device, he again added turpentine and gunpowder and attempted to light it. The tinder was too damp, and he had spent such a long time trying to light it that when he abandoned his attempt, the dockyard gates had been locked.

Eventually, he attracted the attention of a guard who naïvely believed his story of innocent curiosity and allowed him to return to his lodgings. There, the landlady caught him testing his fuses (sheets of rolled paper coated in a mix of charcoal and gunpowder) and she evicted him. The following evening, he returned to the hemp barn and rope house. This time, he lit the tinder from the previous night, but while hurrying away, he bumped into an acquaintance. Worried that they had recognised him, he fled and headed for London, leaving his possessions at the guesthouse.

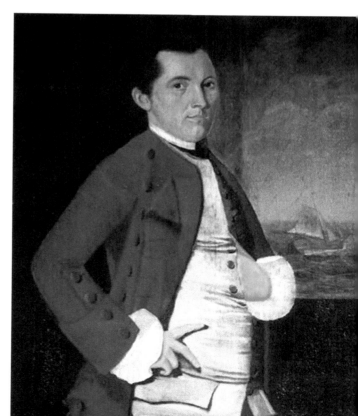

Silas Deane.

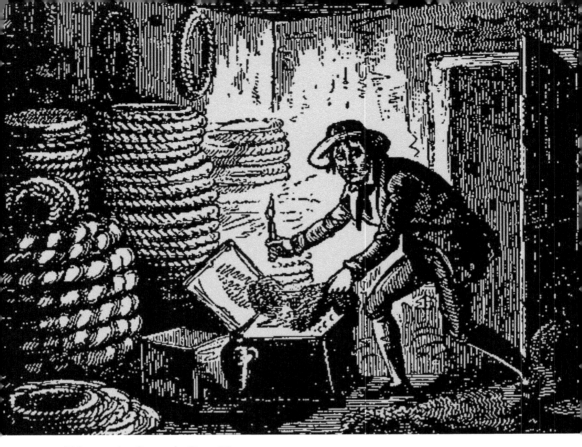

Aitken setting fire to the Rope House.

In London he met his contact, Edward Bancroft, who told him he would have nothing to do with his scheme. Afraid that Bancroft would turn him in, Aitkin headed to Plymouth.

At Portsmouth, the rope house burnt down, but at Plymouth, because of the Portsmouth fire, security had been heightened and guards denied him access to the dockyards. He then travelled to Bristol, where he attempted to set fire to several ships and to some properties with little success. Although his fires failed to catch, evidence was found at each scene and it placed the city on alert. Aitken did destroy several buildings, causing minor damage.

With the discovery of his incendiary devices in Portsmouth and Bristol, authorities linked the two cases, and American revolutionaries and their French and Spanish supporters were suspected. It was quickly established that several witnesses had encountered a housepainter called John prior to the Portsmouth fire, and his description was posted at all Britain's docks. Advertisements were placed in major newspapers, offering rewards for his capture.

Less than a week later, on 27 January 1777, he was in custody, arrested at Odiham, Hampshire, for burglary. In his possession was a French passport, a bottle of turpentine and information on creating fireworks. Although he admitted to several dozen crimes, he was only indicted with three offences at Portsmouth

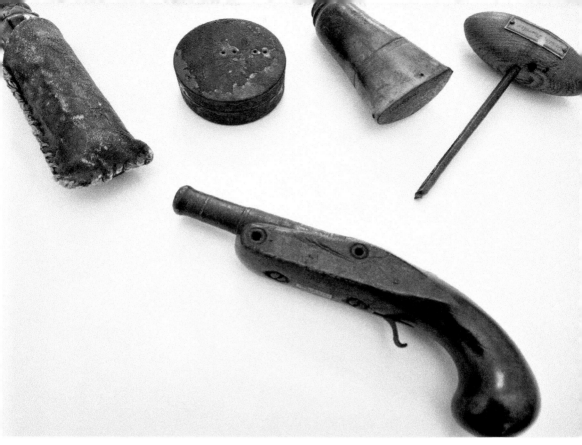

Items in Aitken's possession when arrested.

in which he was charged under the Dockyards etc. Protection Act 1772, with 'Arson in Royal Dockyards'.

For destroying the rope house, attempting to destroy the south hemp house, and the incidental destruction of naval stores, Aitken was tried at in the Great Hall of Winchester on 6 March 1777 before several hundred people. During his trial, which lasted seven hours, the judge sentencing him professed himself at a loss to describe Aitken's misdeeds.

Aitken, still only twenty-four, was found guilty and sentenced to hang. His execution took place outside the walls of the dockyard, on the thoroughfare known as the Hard. He was hanged from a 64-feet mizzenmast and had to be lifted to it by a pulley, giving Aitken the dubious distinction of being hanged from the highest gallows ever erected in England. His corpse was gibbeted and hung at Blockhouse Point, the entrance to Portsmouth harbour for all to see and where it remained for several decades as a dire warning to deter others.

The papers branded Aitken as 'villainous, diabolical, and an atrocious offender'. Although no one died because of his arson, he had caused unprecedented levels of fear, anxiety and worry and was the first person to conduct a successful terror attack in the British Isles. Aitken remains the only person in British history to be convicted of the offence of arson in a royal dockyard.

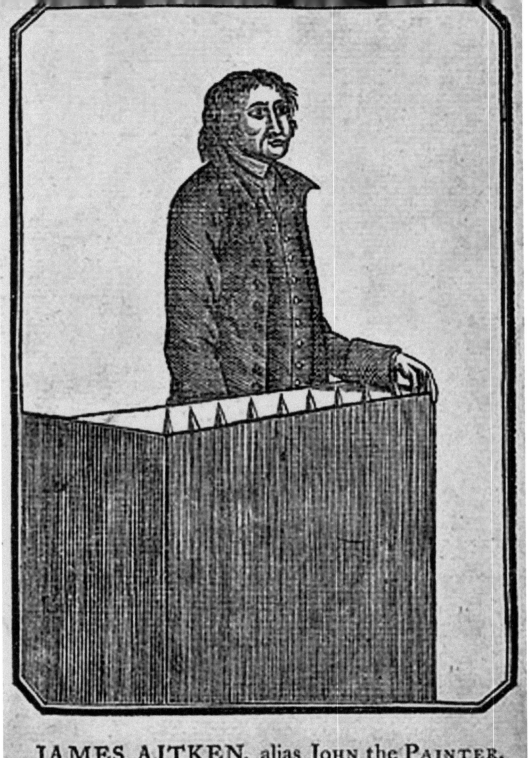

JAMES AITKEN, alias JOHN the PAINTER.

Aitken on trial.

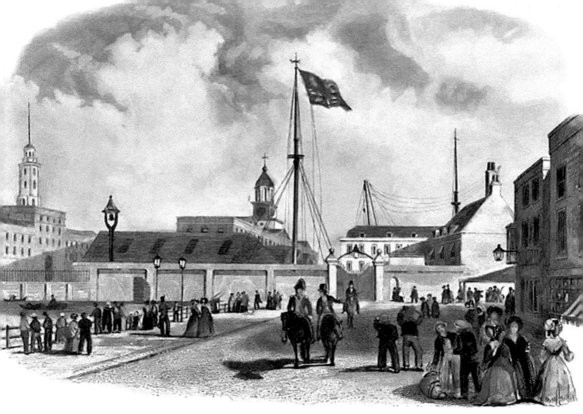

Above: Outside walls of the dockyard, on the thoroughfare known as the Hard.

Below: The Hard today.

Blockhouse Point, *c.* 1800.

His 'last words' were published along with his confession in several editions of the *Hampshire Chronical*, 1777:

> Good people, I am now going to suffer for a crime, the heinousness of which deserves a more severe punishment than what is going to be inflicted. My life has been long forfeited by the innumerable felonies I have formerly committed, but I hope God, in his great mercy, will forgive me; and I hope the public, whom I have much injured, will carry their resentment no further, but forgive me, as I forgive all the world, and pray for me that I may have forgiveness above. I have made a faithful confession of every transaction of my life from my infancy to the present time, particularly the malicious intention I had of destroying all the dock yards in this kingdom, which I have delivered to Mr. White, and desired him to have printed for the satisfaction of the public. I die with no enmity in my heart to his majesty and government but wish the ministry success in all their undertakings; and I hope my untimely end will be warning to all persons, not to commit the like atrocious offence.

WILLIAM BLIGH: 'NEVER FEAR, MY LADS; I'LL DO YOU JUSTICE IF I EVER REACH ENGLAND!'

Mutiny is a criminal conspiracy committed among a group of people (typically members of the military or the crew of any ship, even if they are civilians) to openly oppose, change or overthrow a lawful authority to which they are subject.

In August 1792, an Admiralty court-martial for the offence of mutiny was held on board Lord Hood's ship HMS *Duke*. It took place in the captain's 'great cabin', whilst moored in Portsmouth Harbour. Ten sailors from the Royal Naval vessel HMS *Bounty* were on trial. They were part of a larger group of disaffected men who, in 1789, on route to Tahiti, overpowered the ship's captain, William Bligh. They set him and eighteen of his men adrift on the Pacific Ocean in a 23-foot boat, with nothing more than a ball of twine, some canvas, fishing lines,

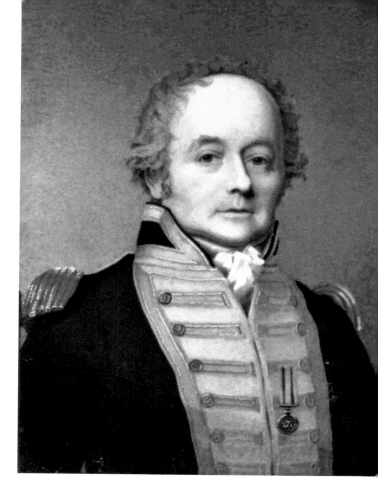

Captain William Bligh.

sails, a 20-gallon cask of water, 150 pounds of bread, a tool chest, a compass and a small quantity of rum.

The final mutiny began in the predawn of April 28. Masters mate, Fletcher Christian, with the master at arms, gunner's mate and Thomas Burkett entered Captain Bligh's cabin while he was sleeping and seized him, tying his hands behind his back with cord and threatening him with instant death if he spoke or made the least noise. They forced Bligh from his bed and took him on deck, wearing only his nightshirt.

Other mutineers ordered the boatswain to lower the *Bounty*'s launch. Fletcher ordered eighteen men loyal to Bligh into the launch. Bligh, now realising what was happening, implored Christian to remember that his children had bounced on Bligh's knee. An emotional Christian replied, 'I am in hell, I am in hell'. The mutineers ridiculed and taunted Bligh before lowering him into the boat. Much to the amusement of the jeering mutineers, Bligh requested arms. At the last minute, Christian tossed four cutlasses into the boat. Christian had kept four men loyal to Bligh on board the *Bounty* against their will, and, as the mutineers cast him away, Bligh called out to them, 'never fear, my lads; I'll do you justice if I ever reach England!'

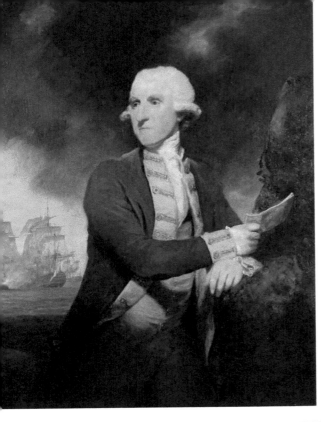

Left: Admiral Lord Hood.

Below: Christian seizing the *Bounty*.

Captain Bligh is set adrift.

Against all the odds eleven months later, Bligh reached the island of Timor, and ten months later, the shores of England. He had survived a six-week sea journey of 3,618 miles in an overcrowded, under provisioned open boat.

Following a court-martial for losing his ship, Bligh was found innocent of wrongdoing. In 1790, the Admiralty dispatched HMS *Pandora*, commanded by Captain Edward Edwards, to reclaim the *Bounty*, capture the mutineers and bring them home to stand trial. After a dogged search, Edwards captured fourteen of the mutineers, but on the voyage to England, the *Pandora* sank during a storm, killing four of them.

Edwards and the remaining ten mutineers, Charles Norman, William McIntosh, Michael Byrne, Joseph Coleman, Peter Heywood, James Morrison, William Muspratt, Thomas Ellison, John Millward and Thomas Burkitt, returned to England in March 1792. The men were tried and sentenced as one. English law stated that it mattered not whether a man actively took part in seizing command of a ship or took no action to oppose the mutiny. They were equally guilty.

Vice-Admiral Lord Hood presided over the court-martial, and Judge Advocate Moses Greetham presented the case for the navy. The trial began on the 12 September with the ten defendants accused of violating Article XIX of the Articles of War. Conviction meant probable death within a few days.

Post-Captain Peter
Heywood.

During the six-day trial, Greetham acquitted Charles Norman, William McIntosh, Michael Byrne and Joseph Coleman on Bligh's testimony that they were innocent loyalists who Christian had forced to remain with the mutineers. Greetham sentenced the remaining six men to death. However, the court appealed to King George IV to grant mercy upon Heywood, Morrison and Muspratt, which he did. All three men returned to service within the Royal Navy.

On the morning of 29 October 1792, a storm raged over Portsmouth and at 11.26, Burkitt and Millward were hanged from the yardarms of HMS *Brunswick*. Their bodies remained hanging for two hours in the pouring rain. Thomas Ellison (seventeen at the time of the mutiny) alleged he was made to hand over his watch at the helm to John Mills and played no part in the mutiny. Ellison's efforts at court to portray himself as loyal to Bligh and unwillingly swept up in events were not favourably received. Heyward gave evidence that he had witnessed Ellison holding a bayonet and saying of Bligh, 'Damn him, I will be sentry over him' and that Ellison was in a crowd of mutineers jeering Bligh and publicly insulting him. Ellison was convicted of mutiny and hanged alongside Burkitt and Millward.

At 13.30, all three men were cut down and their bodies ferried to Haslar for interment in the hospital grounds in an area known as the Paddock and now rest amongst some 8,000–12,000 sailors buried there. Today a few stones remain in the cemetery at Haslar, the area now a memorial garden, and used as a therapeutic centre for military veterans.

Fletcher Christian and other mutineers who evaded capture settled on Pitcairn Island, 1,000 miles east of Tahiti. Twenty years later, in 1808, a whaler dropped anchor at the island and found a community of inhabitants including John Adams, the sole surviving mutineer.

The story of the mutiny on the *Bounty* has been portrayed in several movies, plays and many books and remains one of the most famous events in British nautical history.

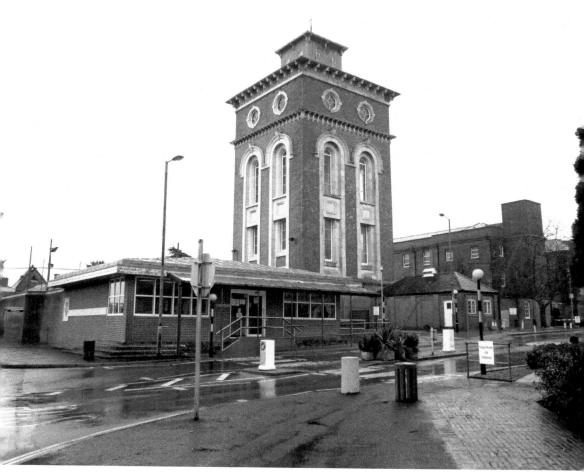

Remains of Haslar Hospital today.

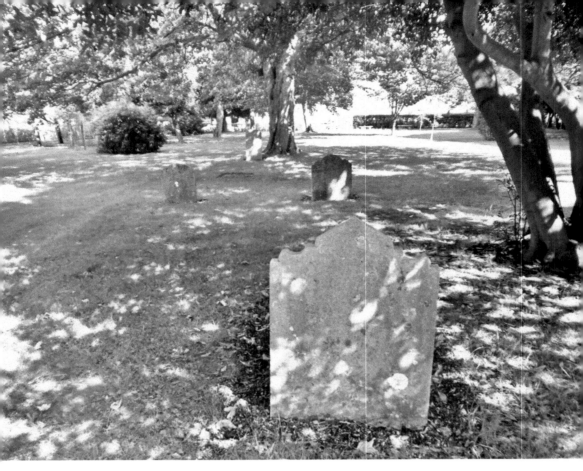

Haslar Hospital cemetery today.

ABOUT THE AUTHOR

Having served eight years with the Royal Army Ordnance Corps in the UK, West Germany and the Falkland Islands as a supply specialist and physical training instructor, Dean joined Surrey Police in 1989 as a police constable, retiring in 2016 as a detective chief inspector.

During his career, Dean served in a variety of detective roles and on several specialist teams investigating crimes of murder, rape, drug supply and other serious crimes. Operating as a detective inspector and detective chief inspector, Dean led and assisted with many high-profile criminal cases within Surrey and its surrounding forces, during which he helped to detect several longstanding unsolved crimes.

In 2010, Dean joined the National Policing Improvement Agency, where he designed and delivered leadership training to senior police officers and police staff equivalents throughout the UK. In 2012, he transferred to the National College of Policing where he continued to provide leadership training and guidance at an international level to police officers from around the world.

During his twenty-six-year career, Dean received many awards and accolades for his contributions to policing including four commendations for excellence and outstanding performance, innovation and professionalism, and dedication to duty, as well as a Judges High Commendation and four Chief Constables Commendations for acts of courage and bravery.

ACKNOWLEDGEMENTS

The production of this book would not have been possible without the help, guidance and support of several people, groups and organisations who have proved invaluable throughout. I am both grateful and thankful to the staff and group members of Hampshire Cultural Trust, Hampshire History, the Hampshire County Council Library Services, Haslar Heritage Group and Rushmoor Writers, without whom it would not have been possible to complete this project.

For the use of their images I acknowledge and thank Richard and Rachael Dunsmore (RD), Mike Faherty (MF), Frank Grant (FG), Peter Trimming, Richard Croft, Oliver Dixon and Dave Doody.

In particular, I would like to offer my heartfelt thanks to friends and fellow authors Jane Sleight and S. Thomson-Hillis for their comments, observations, help, suggestions and, most of all, their encouragement of this enterprise.

Most importantly, I wish to thank my loving and supportive wife, Maria, and two most fantastic friends Richard and Rachael Dunsmore, aka 'Zombie Friend' and 'Running Friend', for their eternal support of my writing projects, many associated adventures, and for the images they gained for me. Sadly, I could not include those you sent me of the of Noobs Lane sign, Gay Lord graffiti or the various food you consumed.

Also available from Amberley Publishing

FARNBOROUGH'S MILITARY HERITAGE
DEAN HOLLANDS

Explore the military heritage of Farnborough from the earliest times to the
present day in this highly illustrated book.
978 1 3981 0161 6
Available to order direct 01453 847 800
www.amberley-books.com

Also available from Amberley Publishing

SUSSEX'S
MILITARY HERITAGE
DEAN HOLLANDS

Explore the military heritage of Sussex from the earliest times to the
present day in this highly illustrated book.

978 1 4456 9517 4
Available to order direct 01453 847 800
www.amberley-books.com